IMAGES
of America

SONOMA VALLEY

Merry Christmas
2013
Don & Barb!

This is to whet your desire
to come to historic Sonoma.
It looks a lot different
now..... better and is filled
with friendly, helpful, civic
minded people. Plus we
are here and would
love to have you come
visit.!!
Warm winter wishes
Sue & Chuck

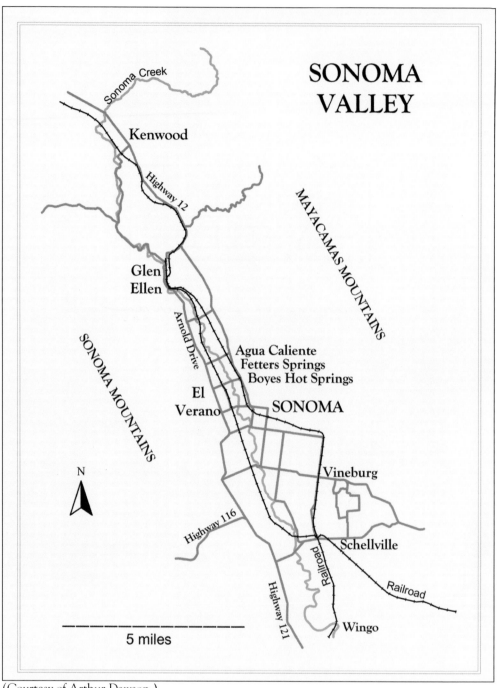

SONOMA VALLEY

Sonoma Creek

Kenwood

Highway 12

MAYACAMAS MOUNTAINS

Glen Ellen

Arnold Drive

Agua Caliente
Fetters Springs
Boyes Hot Springs

El Verano

SONOMA

SONOMA MOUNTAINS

N

Vineburg

Highway 116

Schellville

Railroad

Railroad

Highway 121

Wingo

5 miles

(Courtesy of Arthur Dawson.)

ON THE COVER: Numerous workmen and horse-drawn vehicles surround a recently completed Sonoma City Hall in the center of the eight-acre plaza in May 1909.

IMAGES
of America

SONOMA VALLEY

Valerie Sherer Mathes and Diane Moll Smith
Sonoma Valley Historical Society

ARCADIA
PUBLISHING

Copyright © 2004 by Valerie Sherer Mathes, Diane Moll Smith, Sonoma Valley Historical
Society
ISBN 978-0-7385-2943-1

Published by Arcadia Publishing
Charleston, South Carolina

Printed in the United States of America

Library of Congress Catalog Card Number: 2004111495

For all general information contact Arcadia Publishing at:
Telephone 843-853-2070
Fax 843-853-0044
E-mail sales@arcadiapublishing.com
For customer service and orders:
Toll-Free 1-888-313-2665

Visit us on the Internet at www.arcadiapublishing.com

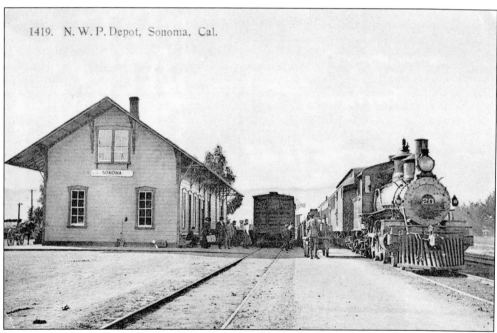

1419. N. W. P. Depot, Sonoma, Cal.

Passengers wait to board Engine No. 20 at the Sonoma Depot on the Northwestern Pacific railway line c. 1910. This depot is located one block north of the Sonoma Plaza, and is the home of the Depot Park Museum and the Sonoma Valley Historical Society.

CONTENTS

ACKNOWLEDGMENTS

These photographs of life in the Sonoma Valley taken primarily during the 19th and early 20th centuries are only a small part of the collection of the Sonoma Valley Historical Society. All images, not otherwise acknowledged in the captions, are from this collection. Therefore without the support of the Historical Society this book could never have been undertaken. The project was a joint effort of Diane Moll Smith, curator of the Depot Park Museum for the Historical Society, and Valerie Sherer Mathes, history professor emeritus from City College of San Francisco.

However, there were many others who aided in the process. Those who were kind enough to share photographs from their private collections include Robert Parmelee, Gary Kiser, Gordon Lindberg, June Picetti Sheppard, Bob and Carol Kiser, the Sonoma Valley Chamber of Commerce, Lena Barsi Davis, and Linda Clark for the Roy Pauli photographic collection. The authors also want to thank Dianne Wishny for her help in the selection of photographs and locating research material, Arthur Dawson for his map, and Robert Parmelee for his moral support and for often setting the historical record straight. Special thanks go to both Don Stevens and Brian Lobsinger who spent hours at the computer scanning these images.

INTRODUCTION

The Sonoma Valley extends from San Pablo Bay to Kenwood and includes the communities of Schellville, Vineburg, Sonoma, El Verano, Boyes Hot Springs, Fetters Hot Springs, Agua Caliente, Glen Ellen, and Kenwood. The history of this valley is a mosaic of cultures beginning with the Coast Miwoks, the dominant tribe. At various times Pomos, Wappos, and Patwins shared the valley. In 1823, two years after Mexico gained independence from Spain, San Francisco Solano Mission was established to Christianize the native groups. When California missions were secularized in the early 1830s, the Sonoma Mission became a parish church for valley residents and all former mission lands passed into private hands. The Indians were dispersed, and Sonoma became a pueblo.

Little more than a decade later, the United States declared war on Mexico. The Bear Flag Revolt in 1846 was the valley's contribution to the war effort. The acquisition of most of the Southwest and California by the United States and the discovery of gold in 1848 in Northern California brought change to the valley as newcomers arrived and old residents returned from the goldfields with newly found wealth.

Efficient transportation was the key to the valley's development. Various types of water craft, which moved both passengers and freight, plied the sloughs of Sonoma Creek, which empties into San Pablo Bay. Railroads, initially running on a narrow gauge track, carried not only passengers and freight, but also promoted the valley's warm climate and fresh produce. Tourism soon became an integral part of life in the valley.

Although many of the historical buildings pictured here still remain, the Sonoma Valley has changed. Automobiles instead of trains bring summer residents and tourists to the valley; orchards, dairies, and hay fields have largely disappeared and dirt roads have been replaced by pavement. But the beauty of the Valley of the Moon has not changed. Its oak-covered hills are ageless and the moon seems exceptionally large as it rises above the valley.

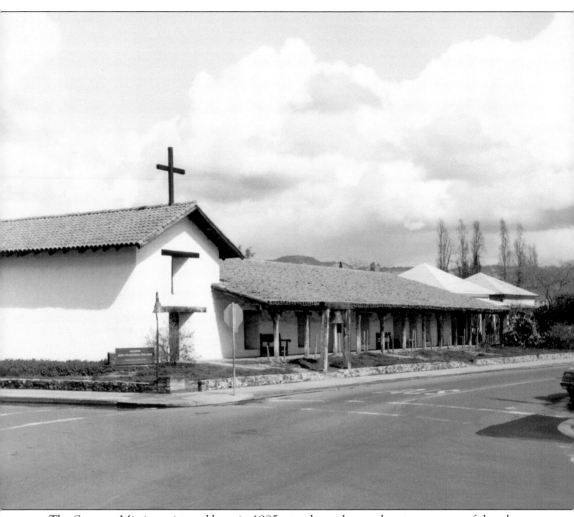

The Sonoma Mission, pictured here in 1985, stands on the northeastern corner of the plaza on Spain Street and First Street East. (Courtesy of Robert Parmelee.)

One

SAN FRANCISCO SOLANO MISSION

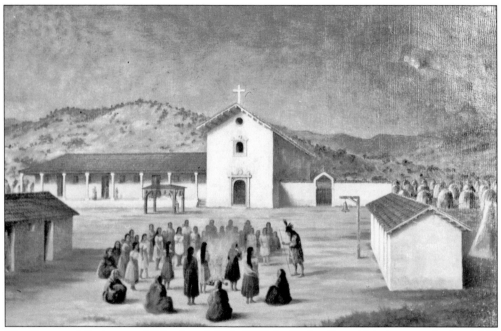

The Sonoma Mission, established on July 4, 1823, by Father Jose Altimira, was the last of 21 California missions. Within eight years its population had grown to almost 1,000 neophytes. When secularization was implemented in the 1830s, Mariano Guadalupe Vallejo, commander of the Presidio of San Francisco, was placed in charge of the mission and its properties. Mission lands were dispersed and most of the former neophytes returned to their native rancherias. The mission chapel, however, continued to serve as a parish church until 1882 when St. Francis Solano Catholic Church was constructed on West Napa Street. Through the efforts of civic-minded citizens, the decaying mission underwent numerous restorations, and today is part of the California State Parks System. Boston-born artist Oriana Day painted this rendering of the mission. Mrs. Day and her daughter traveled to Sonoma by stage in June 1879 and were given the grand tour by Vallejo. Following his suggestion, she included a large gathering of Indians in the foreground. (Courtesy of Robert Parmelee.)

Born in Monterey, California, in 1807, Mariano Guadalupe Vallejo's name is closely linked to the Sonoma Valley. Vallejo came to Sonoma in 1832 under orders to establish a military post north of San Francisco. He was also awarded vast acreage in Petaluma and the Sonoma Valley. As founder of the pueblo of Sonoma, he laid out the plaza, built a two-story barracks for his troops, and constructed two homes, one for himself and one for his brother Salvador. Although Vallejo was arrested in June 1846 by the Sonoma Bear Flaggers, he later served California as a member of the 1849 constitutional convention and as a state senator in the first state legislature.

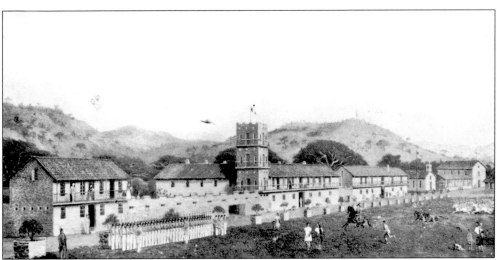

In the hopes of illustrating a book she wanted Vallejo to write, Mrs. Oriana Day painted other valley scenes, including this one of the north side of the Sonoma Plaza, as it was in 1836. This was the year Vallejo was promoted to the rank of commandant general, military governor of the Mexican "Free State of Alta California." Centered in the row of buildings is General Vallejo's residence, Casa Grande, with its 40-foot tower that burned down in 1867. A review of troops by Vallejo and the activities of various horsemen complete the painting. The general spent hours in Mrs. Day's studio sharing information about costumes, ceremonies, and other historical facts.

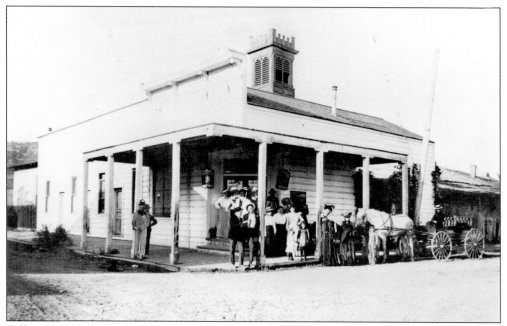

Following the secularization of the California missions, San Francisco de Solano Mission began a slow decline. For many years the buildings were used as a warehouse, a winery, and a storeroom for hay and grain. At one point the saloon shown here was built directly in front of it. The saloon was removed around 1903. (Courtesy of Robert Parmelee.)

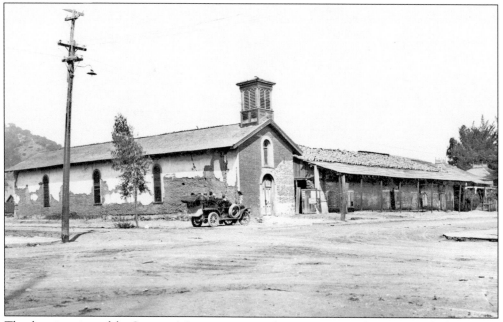

The deterioration of the Sonoma Mission is seen in this street scene taken prior to the beginning of a major restoration in 1910. Civic-minded residents and organizations, including the Sonoma Valley Woman's Club, Native Sons and Daughters of the Golden West, and the California Historic Landmarks League, purchased it in 1903 for $3,000 from merchant Solomon Schocken (Courtesy of Linda Clark.)

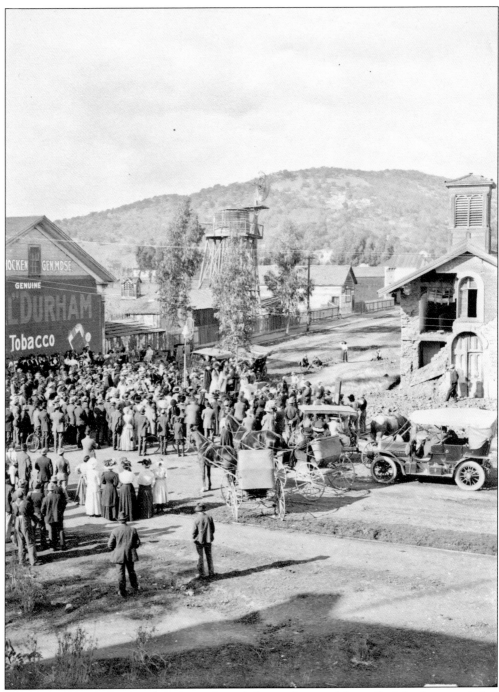

The 1906 San Francisco earthquake weakened the southwest adobe wall of the former mission chapel, causing a bulge. After an especially wet winter, that wall finally collapsed on February 12, 1909. The damage is visible in this October 30, 1909 photograph, as a crowd gathers for the dedication of the El Camino Real Bell at the corner of the mission property. The bell, on a pole above the crowd, is visible in the center. Note the Bull Durham advertisement on the Sonoma Barracks building, which was then owned by Solomon Schocken.

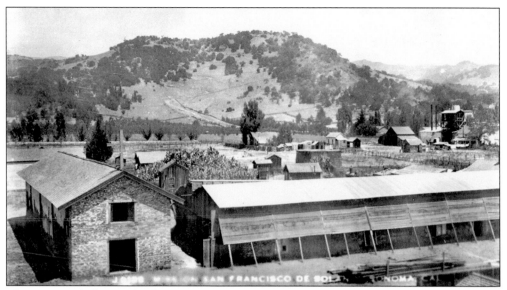

The Sonoma hills are clearly visible behind the mission, which is undergoing restoration in this *c.* 1910 photograph. Other visible landmarks include a road to the quarry, a large stand of prickly pear cactus that remains today, and the Sonoma Ice and Brewing Company to the far right in white. The railroad track runs along the line of trees in the middle. (Courtesy of Robert Parmelee.)

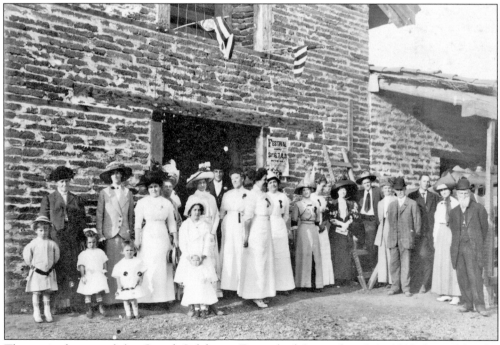

The main feature of the Grand California Festival of September 6–9, 1912, hosted by the Sonoma Valley Woman's Club, was an exhibit of relics from the old Sonoma Mission. Jack London, wearing a tie and a broad-brimmed ranger hat, loaned his collection of South Sea curios to the organizer of the exhibit. His wife Charmian is pictured in the large-brimmed, black hat.

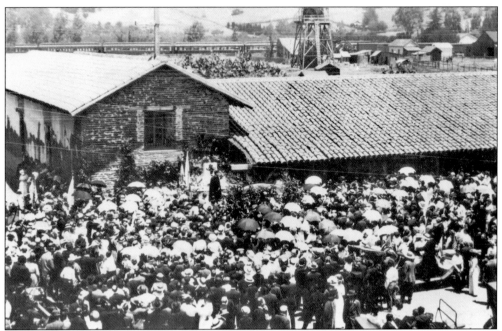

A large crowd gathers in 1914 in front of the Sonoma Mission for a rededication ceremony held at the same time as the unveiling of the Bear Flag monument. Note the train on the Northwestern Pacific's tracks in the background. Many of the visitors who arrived for the ceremonies came by train. (Courtesy of Linda Clark.)

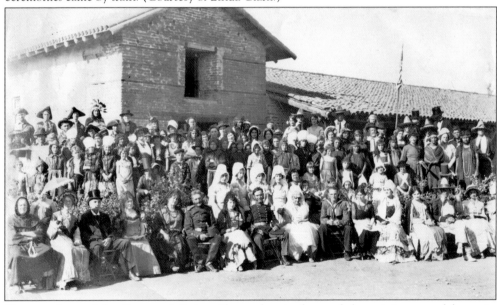

Cast members of the Sonoma Mission Play gather in front of the mission to celebrate its 100th anniversary. This play, produced by Garnet Holme (who also produced the Ramona Pageant in Hemet, California), was performed three times before some 3,500 viewers. Related events during the celebration week of June 30 to July 4, 1923, included concerts, fiestas, a Spanish ball, parades, high mass, theatrical performances, a rodeo, and a fandango. (Courtesy of Linda Clark.)

Two

THE BEAR FLAG REVOLT

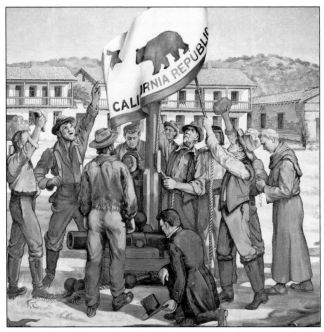

Alphonse Emile Sondag, a staff artist for the National Parks Service and a longtime Kenwood resident, painted this 7-foot by 13-foot mural depicting the raising of the Bear Flag in the Sonoma Plaza for the 1939 World's Fair on Treasure Island. The mural now resides in the Sonoma Depot Museum. The Bear Flag Revolt began on June 14, 1846, when some 33 men seized the small garrison town of Sonoma and took four of its leading citizens prisoner. They were General Vallejo, his brother Salvador, his brother-in-law Jacob Leese, and his secretary Victor Prudon. Fashioning a crude flag with a red star, a poor rendering of a grizzly bear, and the inscription "California Republic," in black letters, this small band of men declared California a republic. What has come to be known as the Bear Flag Revolt was only one small drama in the larger picture of America's first major war of Manifest Destiny, the War with Mexico (1846–1848). The successful capture of the Mexican capital by American forces and the conclusion of the Treaty of Guadalupe Hidalgo added California and much of the Southwest to the United States.

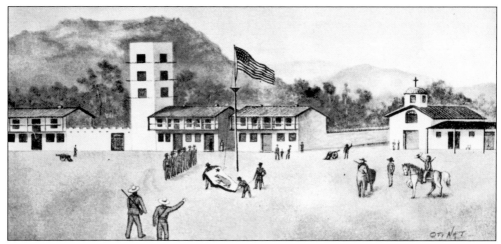

This sketch by Edwin A. Sherman, first city clerk of Sonoma, depicts the lowering of the Bear Flag and the raising of the American flag by Lieutenant Joseph Warren Revere, United States Navy, on July 9, 1846. Today the barracks and the mission are part of the Sonoma State Historic Park, but General Vallejo's headquarters and original family home no longer exist.

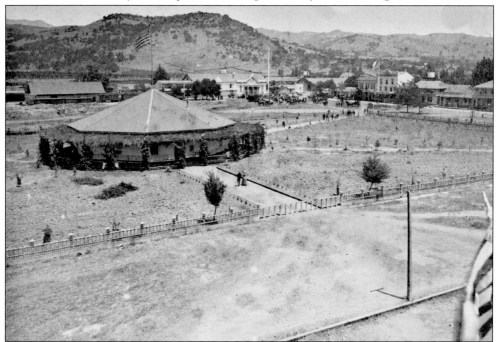

On July 4, 1887, a crowd, including surviving members of the Bear Flag Party, and Mexican War veterans, gather around the flagpole on the northeastern corner of the plaza. The event was organized to promote Sonoma Valley as a desirable place to live and work. Residents were asked to provide food for the visitors. The festivities, advertised throughout the Bay Area, included a reenactment of the raising of the flag by survivors Calvin Griffith, John York, and Harvey Porterfield, and a parade led by the Sonoma Brass Band. The pole pictured here blew down during a severe storm in 1910 and was repaired, but later replaced in 1947 by Mayor August Pinelli and again in 1985 by Pacific Gas and Electric. The pavilion in the center is covered with an arbor and evergreens to provide shade for visitors.

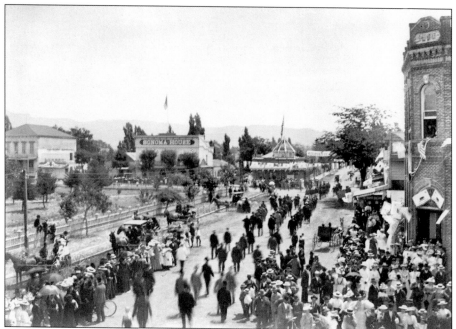

On June 13, 1896, almost 5,000 people turned out for a parade and grand celebration in honor of the 50th anniversary of the Bear Flag Revolt. Excursion trains ran from San Francisco, Petaluma, and Santa Rosa for the event. Participants included Native Sons of the Golden West, delegates from the Grand Parlor of Native Daughters, Mexican War veterans, and members of the Grand Army of the Republic (Civil War veterans). Viewers gather at the intersection of Broadway and Napa Streets. The parade ended at the grandstand near the flag pole in the northeastern corner of the plaza where a welcoming address, the symbolic raising of the Bear Flag, and various other activities were held. The two-story brick Sonoma Valley Bank decorated with replicas of Bear Flags is seen on the right while the fenced plaza is to the left.

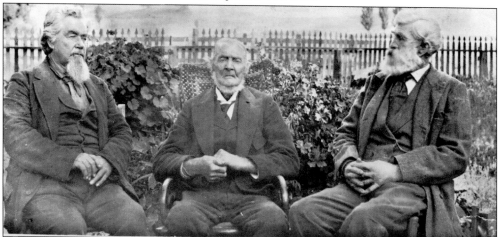

On June 17, 1896, shortly after the 50th anniversary celebration of the Bear Flag Revolt in Sonoma, the three surviving members of the Bear Flag Party gathered at the Carneros Creek home of Harvey Porterfield in Napa. Because of Porterfield's poor health, Henry Beeson, (left) who lived in Mendocino County, and Benjamin Dewell, (middle) who lived in Lake County, traveled to Napa to be photographed with Porterfield at his home.

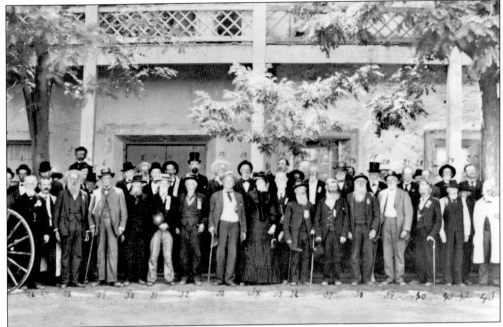

Gathering in front of Salvador Vallejo's adobe on First Street West, California pioneers in June 1896 celebrate the 50th anniversary of the Bear Flag Revolt. Two of the participants were veterans of the original flag raising in 1846.

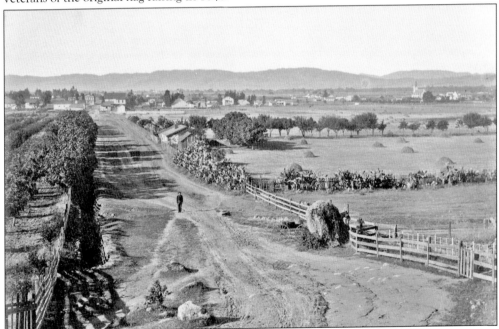

The Native Sons of the Golden West transported the large rock, seen in the foreground of this 1877 view of First Street West, to the Sonoma Plaza (at upper left). This rock was used as the base of the Bear Flag monument that still stands on the north side of the plaza. Today the Sonoma Veterans Memorial Building is located on the left side and the Sonoma Police Department on the right side of the road where this rock once stood.

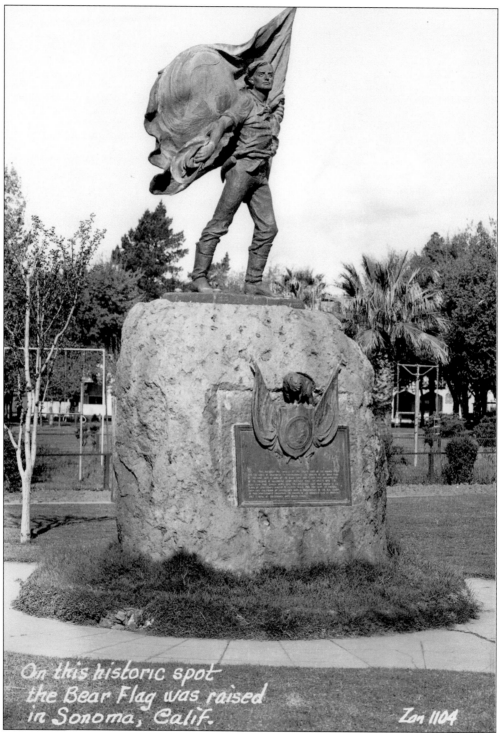

On this historic spot
the Bear Flag was raised
in Sonoma, Calif.

Zan 1104

The statue affixed atop this rock was designed by J. McQuarrie, who also made the memorial to the Donner party at Donner Lake. State funding of $5,000 helped to defray costs. Governor Hiram Johnson attended the unveiling on June 14, 1914, as a crowd of 5,000 looked on.

19

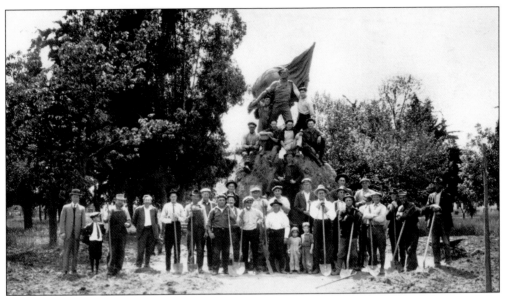

With the Bear Flag monument prominently displayed in the center, the Sonoma Parlor of the Native Sons of the Golden West and friends pose with shovels in hand during a June 1920 clean-up day. The Sonoma Parlor No. 111 was founded in July 1887 by early California-born residents interested in preserving the history of the state. They not only sponsored events to publicize the history of the Bear Flag Revolt, but also helped raise the Bear Flag Monument in the plaza, even digging the hole for the rock they hauled in from First Street West. They were also instrumental in encouraging the State of California to purchase General Vallejo's home. (Courtesy of Gary Kiser.)

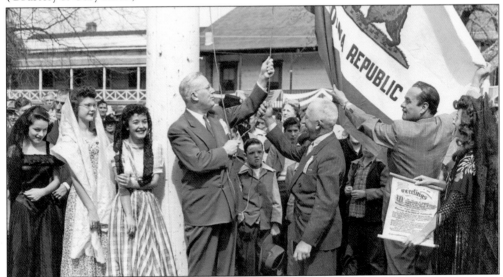

In the center of this March 10, 1946 photograph, California governor Earl Warren participates in a symbolic raising of the Bear Flag, as a prelude to the Bear Flag Centennial on June 14. Sonoma Mayor John Picetti, and screen actor Leo Carillo, known for his TV role as the "Cisco Kid," stand to the right of the governor. The young women to the left include Shirley Gardner, Deana Dodge, and Barbara Friberg, who reigned as queen over the June celebration. More than 50,000 people attended. (Courtesy of June Picetti Sheppard.)

Three

THE SONOMA PLAZA

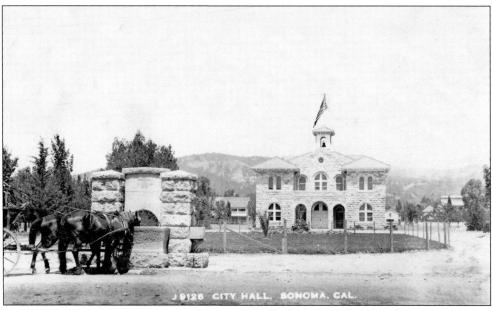

J 9128 CITY HALL, SONOMA, CAL.

Two horses drink from this fountain in front of city hall at the end of Broadway. The Sonoma Valley Women's Club raised $230 in 1905 for this multi-purpose fountain that had an upper trough for horses, a lower one for dogs, and spouts for people. It remained in the plaza until 1932. Sonoma City Hall, dedicated on September 9, 1908, is visible in the background. Today upscale restaurants, boutiques, and wine tasting rooms, many occupying historical buildings, surround the Sonoma Plaza. The mission, the first plaza building, was followed in 1835 by General Vallejo's two-story adobe residence and later the adjacent Barracks, all on the north side. By 1841 both the general's brother, Salvador, and brother-in-law, Jacob Leese, had built homes on the west side of the plaza. Once merely an open space where residents grazed their livestock, the Sonoma Plaza today is well manicured.

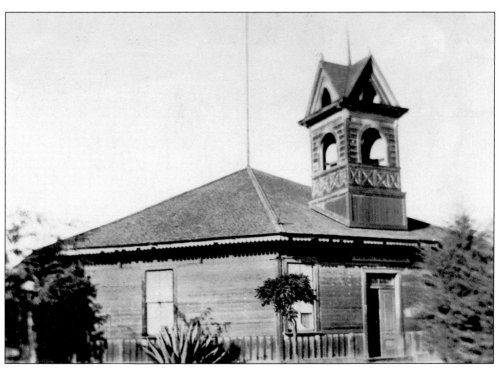

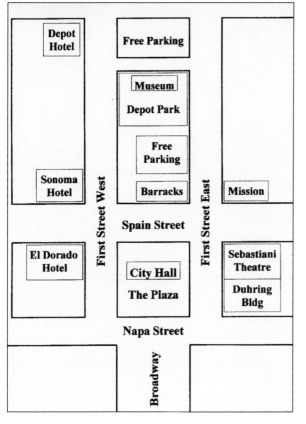

The octagonal "pavilion" was built for $1,600 in the fall of 1880 in the center of the Sonoma Plaza. It served as an early Sonoma City Hall. The fire bell in the belfry not only alerted volunteer firemen, but also rang when President William McKinley was assassinated in 1901. In 1908, the pavilion was sold for $100 to a farmer who tore it down and hauled it away to build a barn.

This is a map of the area around the Sonoma Plaza. Photographs in this chapter begin at Broadway and Napa streets and circle around the plaza counterclockwise. To adequately complete the circuit, it was necessary to use photographs from a variety of different time periods. Many of the structures pictured herein no longer exist. (Courtesy of Don Stevens.)

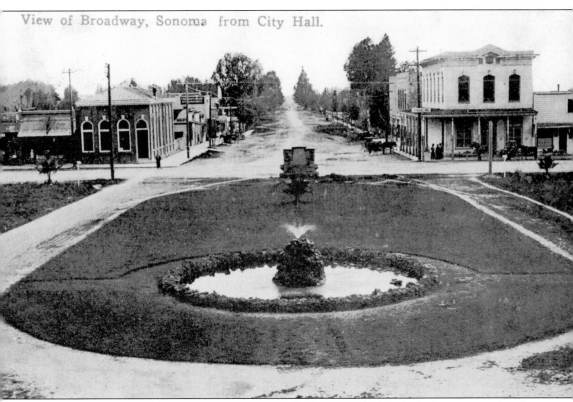

Taken from the upper floor of Sonoma City Hall, this view looks south down a tree-lined Broadway. In the center of the photograph, the rear of the Sonoma Valley Woman's Club fountain is visible along with various small palm trees that still stand today. The fish pond and fountain in the foreground were added in 1909. The brick Sonoma Valley Bank is on the left and the two-story Clewe General Merchandise Store on the right.

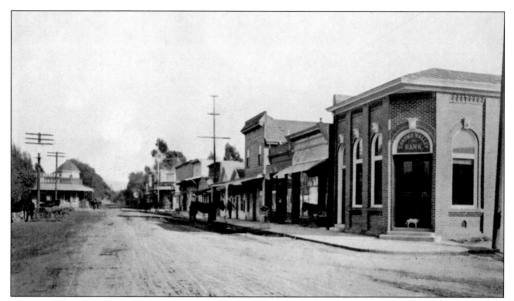

The Duhring building on Napa Street and First Street East is visible in this view looking east with the plaza to the left. The brick Sonoma Valley Bank, only one-story in this view, is on the far right.

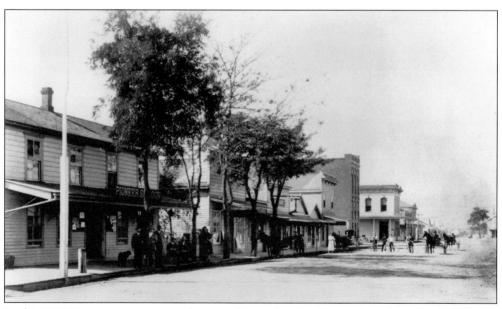

In this 1892 Sonoma street scene, showing the south side of Napa Street between First Street East and Broadway, the Pioneer Saloon can be seen on the far left. It was replaced ten years later by the present-day Hotz building. Most of the wooden buildings between the Pioneer Saloon and the Sonoma Valley Bank no longer exist. The second floor of the brick Sonoma Valley Bank, seen in this view, was later damaged during the 1906 earthquake and was removed.

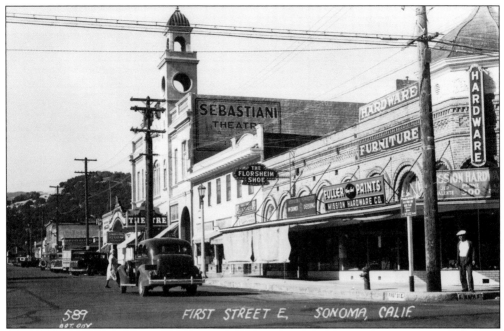

Taken in the late 1930s, this street scene of First Street East, looking north, includes the Sebastiani Theatre, built in 1933 by Samuele Sebastiani, and the Mission Hardware Company in the Duhring building on the right. The theatre opened on April 7, 1934, with *Fugitive Lovers*, starring Robert Montgomery and Madge Evans. More than 1,000 residents attended on that day.

This 1900 view of the same section of First Street East shows the adobe buildings that lined the street. A 1911 fire destroyed most of the buildings pictured here except for the two-story Sonoma House to the right. The Sonoma Mission can be seen at the far end of the street.

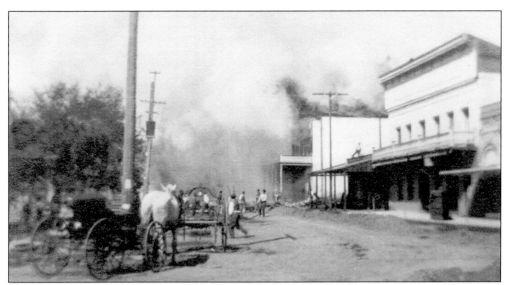

The explosion of a coal oil stove in a small kitchen in a cobbler's shop on September 23, 1911, spread quickly and engulfed much of the business block on First Street East. Property destruction was estimated at more than $40,000. Although nearly 100 firefighters arrived on the scene within five minutes, the fire was spurred on by a brisk breeze. A change in wind sent the flames on to buildings to the north. When the roof of Pinelli's wine cellar on Spain Street caught fire, Pinelli helped volunteer firemen connect to his 1,000-gallon tank of wine in the cellars of a structure (now a florist shop) next to the Blue Wing Inn. His building was saved. The furniture that was removed from these doomed buildings was placed in the plaza. When the wind changed direction, flames ignited the grass, and all the rescued items were destroyed.

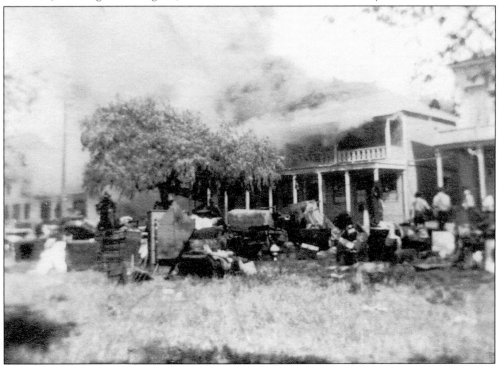

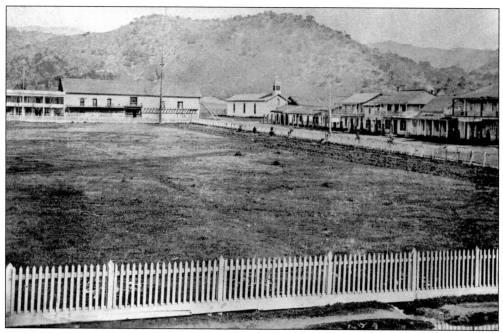

In this view of the northeastern corner of the Sonoma Plaza taken in 1871, the Sonoma Mission can be seen in the center with the barracks to the immediate left, and the adjoining Toscano Hotel. The adobe structures on First Street East were later destroyed in the 1911 fire. The eight-acre Sonoma Plaza is bordered by a picket fence.

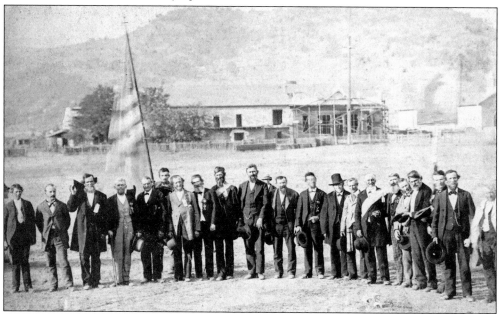

Early California Pioneers (residents prior to statehood in 1850) from Sonoma and Napa Counties pose in the plaza in September 1879. Part of the mission chapel building and the barracks, with scaffolding used to add the wooden Victorian facade, can be seen in the background. General Vallejo, who had originally laid out the town of Sonoma around a central plaza, had ordered the construction of this adobe building.

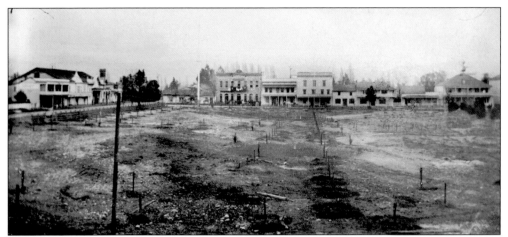

Landscaping is evident in this view of the northeastern corner of the plaza after 1891. The two-story stone structure slightly to the left of center was built in 1891 by Augustino Pinelli, who came to Sonoma in the early 1880s. On the left are the Toscano Hotel and the former Sonoma Barracks, with its ornate Victorian wooden facade painted white. It was added by merchant and owner Solomon Schocken c. 1879. Schocken sold groceries, dry goods, clothing, boots and shoes, hats, notions, cutlery, tobacco, tin ware, hardware, tea, flour, and feed from his store. He also served as agent for the California Spool and Silk Company and for the California Home Mutual Insurances Company.

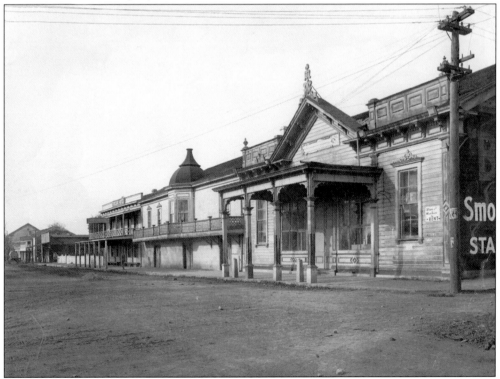

To the right, on the corner of First Street East and Spain, is the Schocken store in the remodeled barracks. To the left are the Toscano Hotel, a blacksmith shop, and the Swiss Hotel at the end of the street.

28

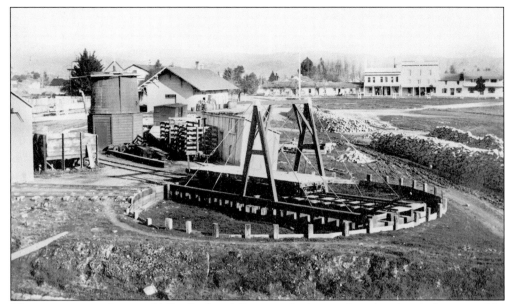

The narrow gauge Sonoma Valley Railroad Company had its yard on the plaza with a turntable, car barn, engine house, water tower, depot, and repair shed. The depot, shown in this photo, was built in 1880 on the south side of Spain Street across from the current Sonoma Cheese Factory. It was moved a decade later, one block north to its present location on First Street West. The buildings along First Street East can be seen in the upper right. The piles of locally quarried stones to the right of the turntable were loaded onto trains and shipped to San Francisco to pave its streets.

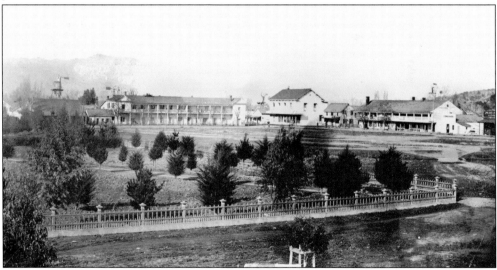

The railroad yard has been removed in this 1890 view of the northwestern corner of the plaza. To the left of the tall two-story Weyl Hall (present-day Sonoma Hotel) is the two-story Salvador Vallejo adobe. During the late 1850s this building, then only one floor, housed the Sonoma Academy later known as Cumberland College. Classes included science, math, foreign languages, embroidery, drawing, music, and painting. A second story was later added to the structure to provide housing for student boarders. To the right of Weyl Hall is the second two-story adobe owned by Salvador Vallejo (present-day Swiss Hotel).

The buildings along First Street West are visible in this 1870s scene of the southwest corner of the plaza with part of the Leech-Fitch adobe to the far left. From left to right are a blacksmith shop, the Liliburn Boggs home, set back from the street, a small store, a tailor shop, and the two-story Salvador Vallejo building. This picket fence was built by the Society of California Pioneers for Napa, Sonoma, Lake, Mendocino and Marin Counties. Tony Oakes, proprietor of the Union Hotel in the 1850s and 1860s, poses in a top hat along with several other men. Oakes, known for his guitar playing, served as a member of the city council and as mayor of Sonoma in 1857 and 1858.

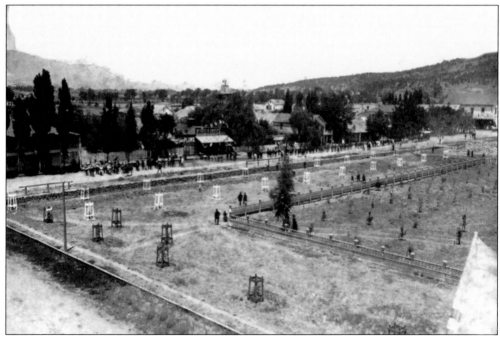

A later view of First Street West shows a different fence and another attempt at landscaping. A parade led by the Sonoma Valley Band moves down the street lined with hitching posts. Also visible is the rock-lined drainage ditch designed to contain the runoff from the hills. This ditch began at Mountain Cemetery and ran down the street beyond the Union Hotel.

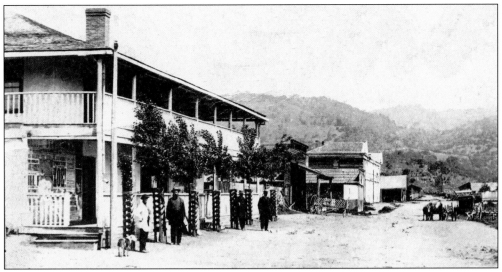

Built in 1845 by Jacob Primer Leese, the Leese-Fitch Adobe is located on the corner of First Street West and Napa Street. This building, the first in the valley with an interior fireplace, served as both a home and a mercantile business. It was also the first non-religious, non-military structure in Sonoma. This adobe was later sold to General Vallejo, who in 1849 sold it to his wife's sister, Josefa Carrillo Fitch. Leese, photographed here with his wife, Rosalia, and their seven children, came west over the Santa Fe Trail and then to San Francisco. He moved to Sonoma where he became the town's first merchant and the husband of General Vallejo's sister, Rosalia. From 1844 to 1845 he served as the town alcalde. During the June 1846 Bear Flag Revolt, Leese, along with his brother-in-law and two others, was captured and taken to Sutter's Fort in Sacramento. A prominent land owner, a successful placer miner, and a profiteer in the China trade, he died penniless.

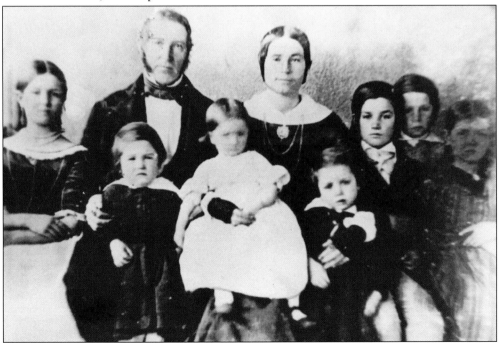

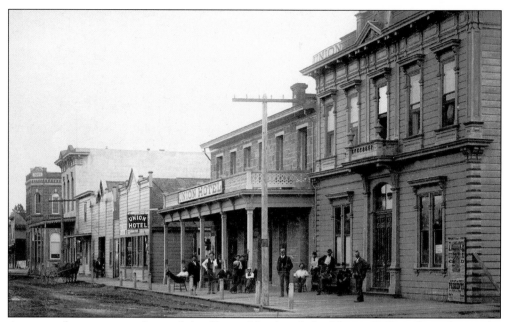

A group of men pose in front of the Union Hotel and the Union Hall to the right on the south side of Napa Street between Broadway and First Street West on September 25, 1895. This two-story stone hotel replaced an earlier adobe hotel that burned down in 1866. The adjacent two-story wooden Union Hall, built around 1885, was large enough for dances and high school basketball games. Social and civic events were also held here. In 1956 both the hotel and adjoining hall were demolished to make way for the construction of the Bank of America building. The two-story Sonoma Valley Bank is on the far left.

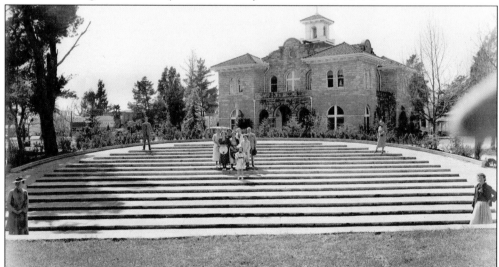

This 1935 or 1936 photograph of the Sonoma amphitheater, with the city hall in the background, includes members of the Lloyd Simmons family. The amphitheater, built with the support of the Public Works Administration, was dedicated on May 31, 1935, during a Memorial Day celebration. In June 1970 it was renamed Grinstead Memorial Amphitheater in memory of Judge Allen Ray Grinstead, prominent civil leader and councilman, and a leading proponent of plaza beautification.

Four

SONOMA VALLEY BUSINESSES

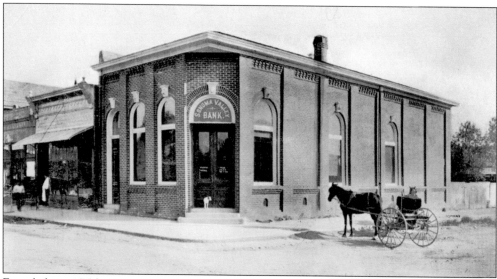

Founded in 1875 by David Burris, the Sonoma Valley Bank moved into a new two-story Neo-classic style brick building on the corner of Broadway and Napa Street in 1891. Before the structure was damaged by the 1906 earthquake, the second floor housed the Temple Lodge. In addition to this bank, Sonoma had two bakeries, a meat market, a druggist who also sold stationery, paints, candy and tobacco, two shoe stores, a lumber yard, a general news depot, and a dozen saloons in the 1880s. Others businesses included carpenters, barbers, sign painters, a notary public, several lawyers and physicians, three blacksmiths, a harness maker, and livery stables. In other valley locations, small business developed around the train depots. As the population in these outlying areas grew, new businesses emerged to meet the needs of its residents. (Courtesy of Linda Clark.)

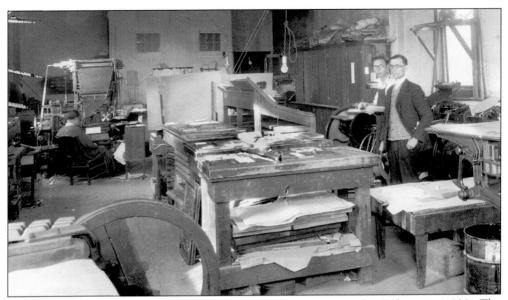

Three men pose inside the composing room of the *Sonoma Index-Tribune* in 1930. The newspaper, which celebrated 125 years of publishing history in 2004, was started in 1879 by Benjamin Frank. During its first five years, over a dozen owners operated the paper until Harry Granice, great-grandfather of the current publishers, Bill and Jim Lynch, bought the paper in 1884. One of the first newspaper offices was in the Clewe building at the southwestern corner of Napa Street and Broadway.

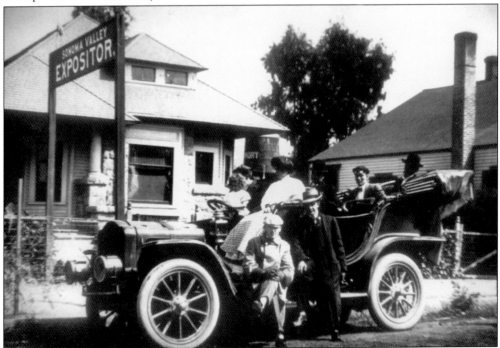

The *Sonoma Valley Expositor* was an early Sonoma newspaper printed from 1899 to 1912. It was issued every Friday for a subscription price of $1.50 per year. Single copies sold for 5¢. From 1919 to 1925 the newspaper resumed publication as the *Expositor Forum*.

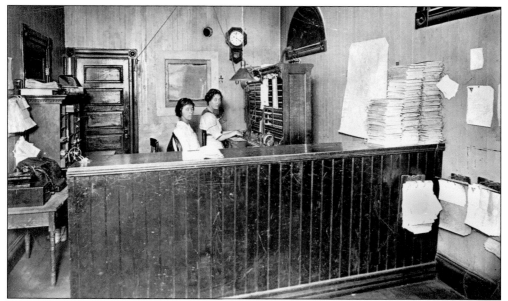

In this 1915 photograph, Nellie Peterson and Josephine Steiner Andrieux sit at the switchboard of the California Telephone and Light Company, expertly handling the calls of the 150 subscribers. Pacific Telephone and Telegraph Company took over in 1930.

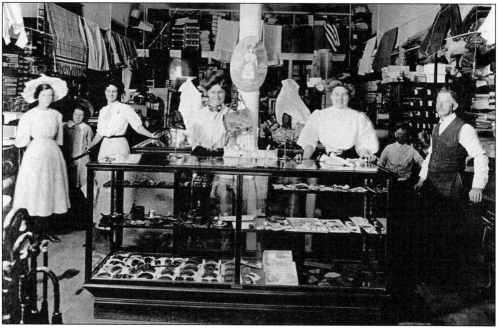

The G.H. Hotz Dry Goods Store, founded in the 1880s by Gustav Henry Hotz, was located on Napa Street midway between Broadway and First Street East. This 1897 photograph shows the millinery department operated by Mrs. Emma Hotz, who is third from the left. In 1903, this location became the Simmons Pharmacy and Hotz moved to a new building on the southwestern corner of Napa Street. Hotz, who remained in the dry goods business for a half century, was active in educational and civil work. His sons Harold and Ralph continued to operate the business until the 1970s.

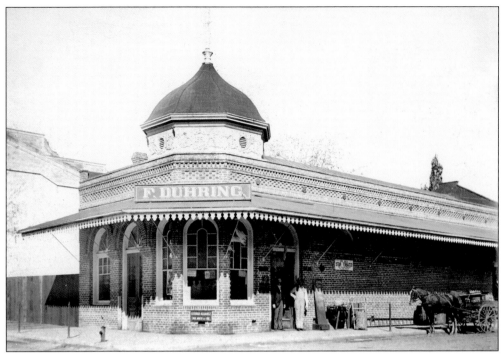

Frederick and Dorothea Duhring arrived in Sonoma from Germany in the 1850s. By 1859 they were running a successful general store on the northeastern corner of Napa Street East and First Street East. In 1891 their son Frederick T. Duhring replaced the original adobe building with the brick structure pictured here. The property remained in family hands until August Pinelli and partners took over the business in 1932. In 1911 this brick building narrowly escaped a raging fire that destroyed most of the rest of the block, but in September 1990 the building, then housing Mission Hardware, burned down. Clerks Jerome Jensen and George "Monk" Goess are shown in the interior of the Duhring store in this 1911 photograph.

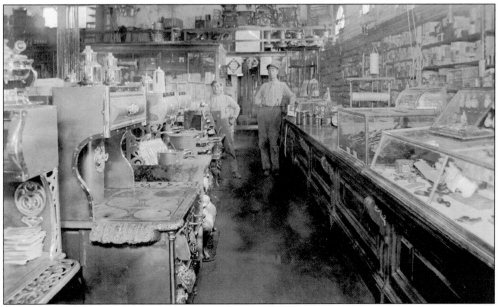

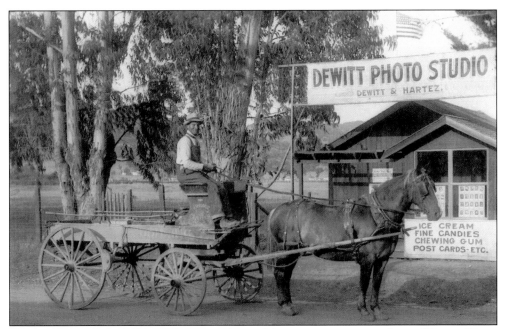

George Perazzo, driver of the Duhring one-horse delivery wagon, stops in front of Dewitt Photo Studio, located across from the Sonoma Grove Resort on Highway 12, near present-day Maxwell Village. Note that the photo studio also sold ice cream, candy, chewing gum, and postcards.

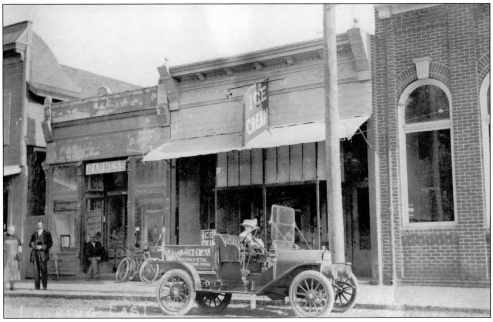

Lutgens' Ice Cream and Candy Store, located on East Napa Street near the corner of Broadway, was opened in the summer of 1903 by Mrs. Lizzie Lutgens, daughter-in-law of John Henry Lutgens. Lutgens rebuilt the Union Hotel in stone following the 1866 fire that destroyed the earlier adobe hotel. The candy store remained in business until it was sold in 1923. Note "Artie" Lutgens's right-hand drive Studebaker parked in front of his mother's candy store.

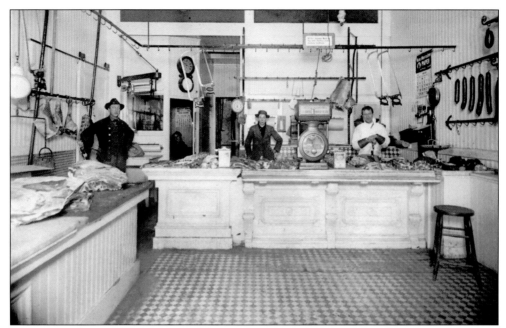

This is a 1915 view of the interior of the Lewis and Cummings Butcher Shop, located on West Napa Street. Shown here from left to right are: Sam Lewis, Gus Alber, and Gus Weyl. Lydia Culberson, the bookkeeper, can be seen sitting in her office beneath the clock. Note the wall sign which reads "All our sausage made in our own factory under sanitary conditions." "Lewis & Cummings, we guarantee honest weight," appears on the meat scale.

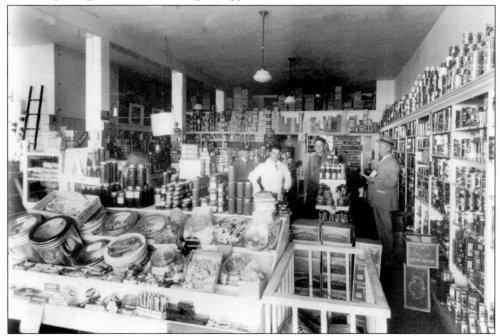

Gottenberg's Grocery Store, located in the 500 block of Broadway, was owned by James C. Gottenberg and his brother Ray. Butcher Attilio Giacopazzi, in white, with Jim Gottenberg, Louie Minelli, Tony Desposito, and Ray Tynan are shown in this late 1930s photograph.

Lloyd Scott "Doc" Simmons, who established his pharmacy in 1903 on Napa Street, leans against the soda fountain in this c. 1930 photograph. He concocted most of his medicines, including his "Sure Cold Cure," which sold for 25¢ and was reputed to cure a cold in only one day, and a freckle cream for his young daughter Gladys Florabel. Charmian London was a frequent visitor at the white marble fountain counter, visiting with Simmons and eating his homemade ice cream while her husband, Jack, visited the various bars around the plaza. Simmons, an amateur photographer, published many of his early photographs as postcards. The first telephone switchboard was located in the pharmacy, and Mrs. Mabel Greeley Simmons ran the board during the day.

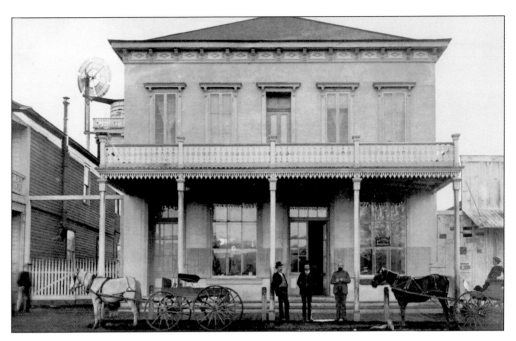

Julius Adolph Poppe and his wife, Catherine, opened their general merchandise store on First Street East in 1860 (top). The upstairs of this two-story building, which was rented out for meetings and dances, became known as Poppe's Hall. When Mr. Poppe died from a fall from his roof in 1879, Catherine and her adult children continued to run the store until it was destroyed in a fire in 1911. Catherine's son Robert initially opened his law office in a corner of the store, but following the fire, rebuilt a larger office at a vacant site. Following his father's death, Charles J. Poppe helped his mother run the family business in Sonoma until he moved to Glen Ellen to open his own general merchandise store in 1883, pictured below. He remained as proprietor until his death in 1926. A prominent civic leader, Charles Poppe was the Glen Ellen postmaster from 1890 to 1916 and a member of the local school board for twenty-six years. The building pictured here burned in 1905 and a new two-story stone structure was built in its place.

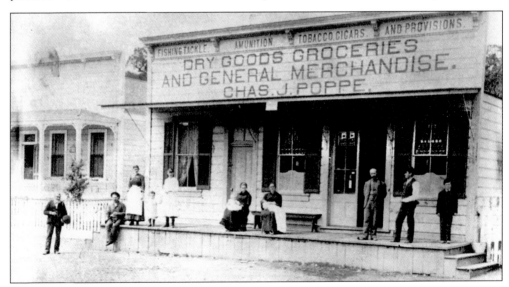

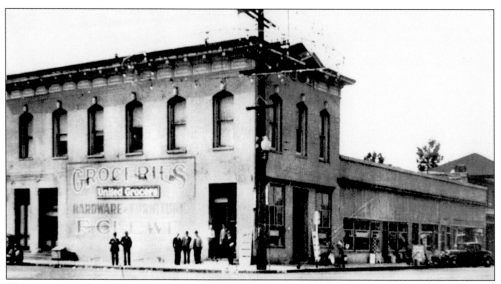

Clewe's General Merchandise Store, located on the southwestern corner of West Napa Street and Broadway, was established in 1882 by Johann Clewe, a pioneer merchant. He sold ready-made clothing, groceries, hardware, glassware, drugs, medicines, books, stationery, paints, and tobacco. In addition, in 1890 the first telephone exchange in the valley was established in the store. After the Sonoma Valley Union High School building was damaged during the 1906 earthquake, high school classes were held in rooms on the second floor of the store. Today this section of West Napa is occupied by Washington Mutual Bank.

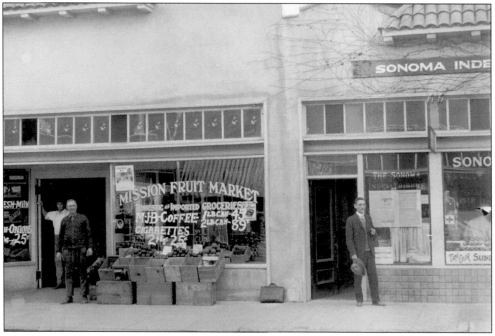

According to the advertisement painted on the window, both domestic and imported groceries were sold in Bautista Mori's Mission Fruit Market. In this 1930 photograph, Bautista Mori, right, and his son, Carlos, stand in the doorway of his store while Wade Wilson stands in front of the *Sonoma Index-Tribune* newspaper office, both located on West Napa Street.

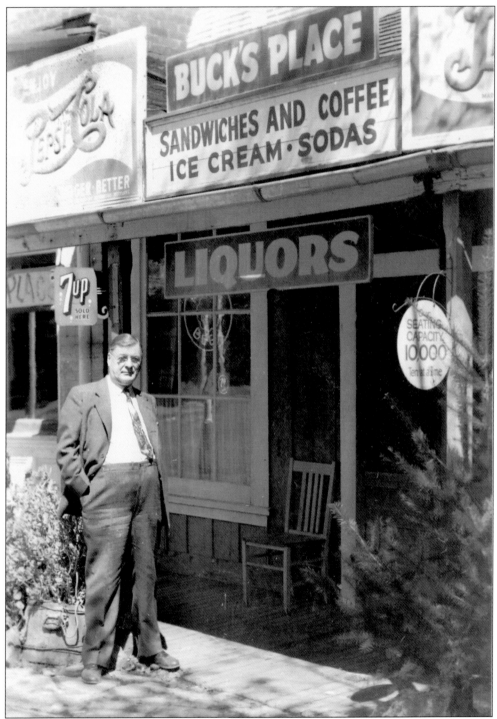

Henry Buck stands outside his tavern in the center of Glen Ellen across from Charles J. Poppe's store. Note the clever sign: seating capacity 10,000, ten at a time. During Prohibition, the business had an ice cream parlor facade, and panels installed behind the bar cleverly hid the liquor.

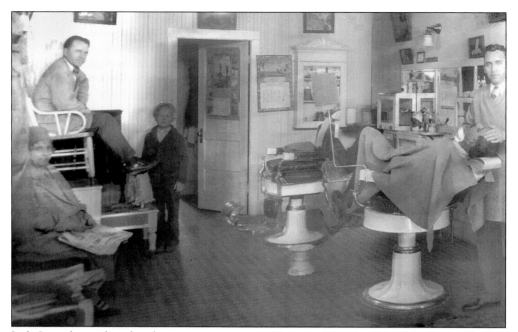

Jack Sims shaves friend and one-time partner, Willis Jones. The shoeshine boy pictured here is Les Martinson. Sims, who came to Sonoma in 1926, bought his first barber shop on First Street East, next to the Sebastiani Theater. From this location he could easily look out over the plaza, which he described as "a weed field," where residents brought their family cows to eat the grass.

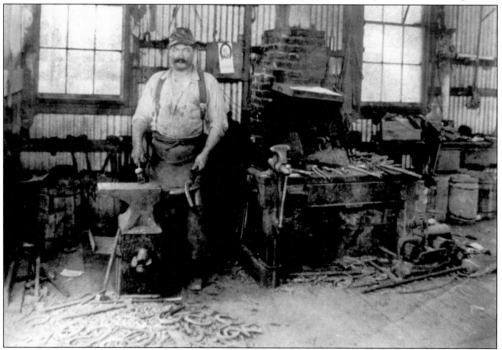

A smithy poses in front of an anvil surrounded by horseshoes in William D. Rambo's Blacksmith Shop. Various tools of the trade lay around the brick forge in the center of the photograph. In addition to general repairs in both wood and iron, Rambo made wagons.

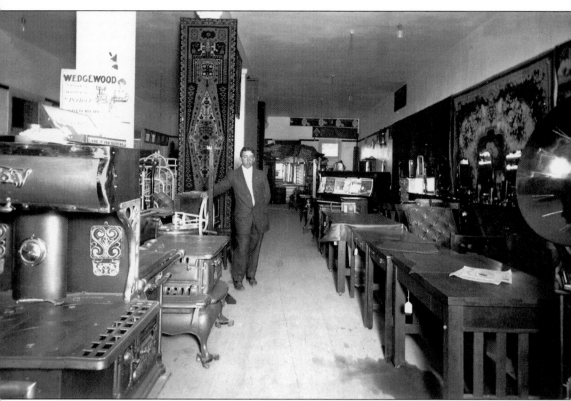

A young John F. Picetti stands inside his Sonoma Valley Furniture Company on the corner of West Napa and First Street West. He ran this establishment from 1911 to 1916, part of the time with his brother, Louis J. Picetti. Later the brothers managed their father's ranch on the old Napa Road. A prominent civic leader, John Picetti served on the Sonoma County Planning Commission for a decade, on the Sonoma City Council, and in 1942 became the mayor of Sonoma. (Courtesy of June Picetti Sheppard.)

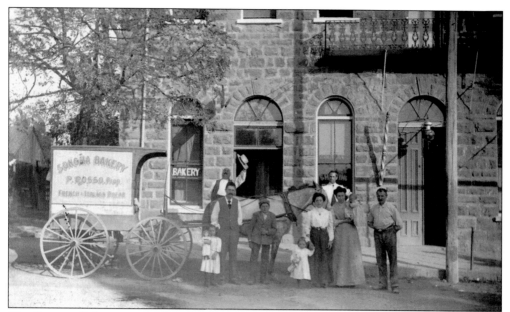

The Sonoma Bakery, one of the many bakeries that rented space over the years in the Pinelli building on First Street East, specialized in French and Italian breads. P. Rosso, seen waving in the photograph, was the proprietor.

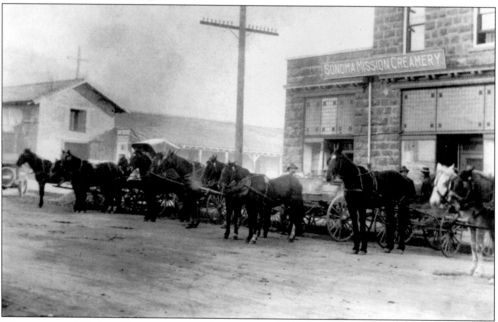

The Sonoma Mission Creamery, an early commercial cheese and butter factory in the valley, was owned by Joseph Vella and his partners. August Pinelli remembered collecting 10-gallon cans of milk from various dairies and delivering them to the door on the left in this photograph. The separated cream was then made into Valley of the Moon brand butter, and the skimmed milk was turned into Monterey jack, a versatile product, easily sliced and fried. In 1918 the Creamery purchased 3,154,204 pounds of milk from local dairies; in 1922 the amount purchased rose to 5,282,763. Note the Sonoma Mission on the far left in this 1917 photograph.

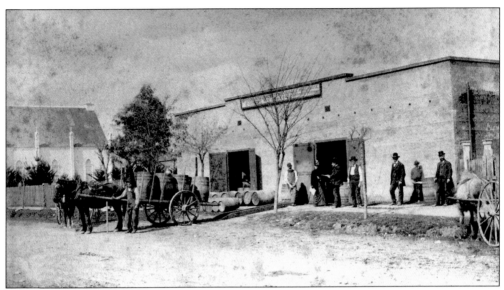

This horse drawn wagon loaded with barrels is about ready to leave the Internal Revenue Bonded Warehouse, located on West Napa Street near the St. Francis Solano Church, visible to the left. Liquor and brandy were stored in the warehouse and when released, were reported and taxed.

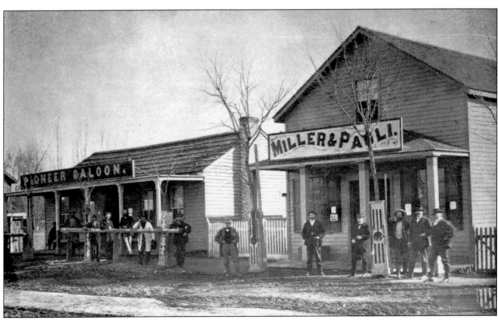

The Pioneer Saloon, owned by Lewis Adler, and the Miller and Pauli mercantile store, were located on East Napa Street, on the south side of the plaza between Broadway and First Street East. These were popular businesses during the 1870s and 1880s. Along the rail from left to right are Mr. Reinke, Lewis Adler, Jacob Gundlach, Salvador Vallejo, Julius Dresel, Franklin Watriss, and in front of Miller & Pauli, George Lewis, unidentified, unidentified, Doc Pauli, and G.V. Stewart. Gundlach and Dresel were partners in Rhinefarm (part of today's Gundlach-Bundschu Winery), and Gus Pauli served as Sonoma County treasurer from 1869 to 1875.

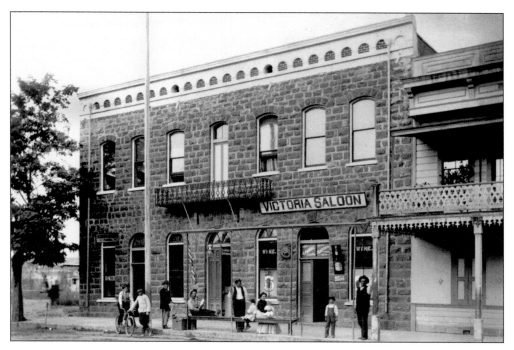

Residents stand in front of the Pinelli Building on First Street East. In 1891 Augustino Pinelli built this structure from locally quarried stone. The south end of the building housed his Victoria Saloon and the north side was leased to P. Manfredi and Company for an Italian bakery and grocery store. In the bottom photograph, Italian-born Augustino Pinelli stands behind his bar in the Victoria Saloon. To the left is Emil Pinelli. A wide variety of liquors are displayed against a Victorian era wallpaper backdrop with a Mille Liberty Bell slot machine on the bar.

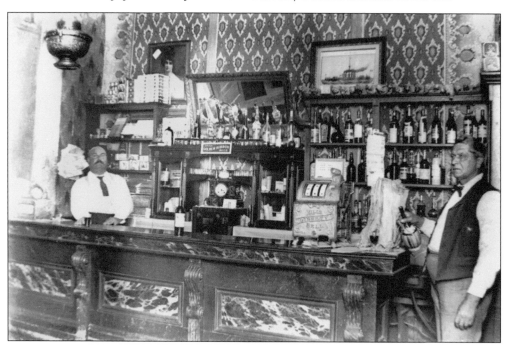

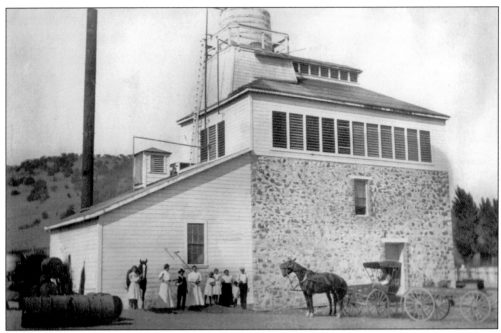

Established in 1905 by John Steiner and investors, the Sonoma Brewing Company on Second Street East brewed steam beer and lager, and for a short time during Prohibition, "near beer." The stone building with its wooden cooling tower is viewed from the south side. A fire in 1952 destroyed the wooden structure and much of the interior. The building was purchased by Tom Vella and remodeled. Since 1968, the Vella Cheese Company has occupied this structure.

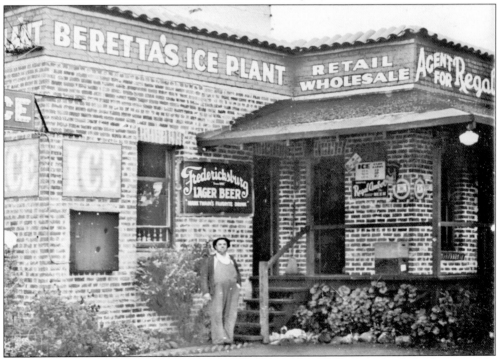

Located on First Street East, Angelo Beretta's Ice Plant also sold beer and soft drinks.

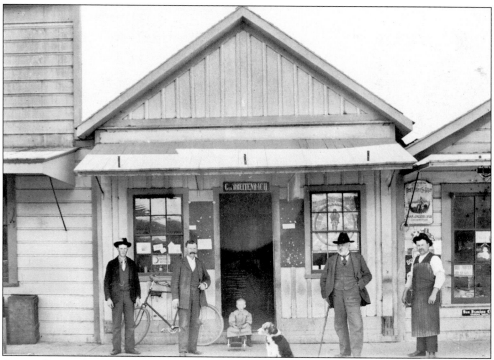

George Breitenbach's Harness and Bike Shop was located across from the plaza on East Napa Street, three doors east of Broadway. Breitenbach, who was active in civic affairs and served as Sonoma's mayor in 1908–1909, manufactured all types of harnesses and served as agent for the Hercules harness, which he considered the best made factory harness on the market. He also sold bicycles and parts. From left to right in this 1896 photograph are Reynald McDonnel, Gustav Henry Hotz, Lloyd Hotz, Colonel Bob Atwood of Kentucky, and proprietor George Breitenbach, with Carlo the dog. Breitenbach stands among bicycles and harnesses in this 1903 photograph of the shop's interior.

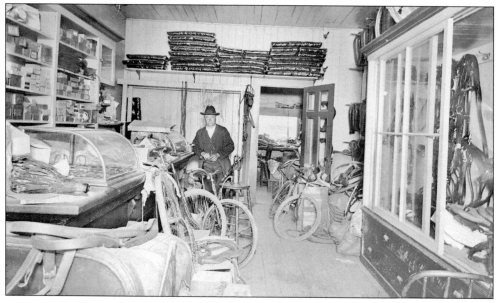

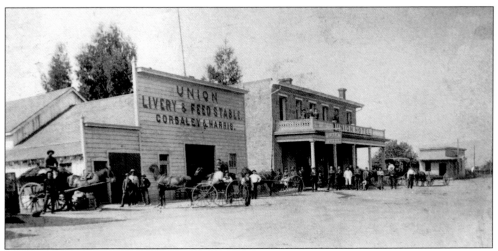

The Union Livery and Feed Stable stood next to the Union Hotel on Napa Street. Boarding horses and leasing rigs day and night, it was described by the *Sonoma Valley Expositor* in January 1899 as up to date, and "one of the largest and best appointed livery and feed stables." The paper further noted that the horses "received the best of attention while the feed is of the best quality and liberally served," and that the barn was headquarters for the stage that carried passengers back and forth from the Southern Pacific Railroad.

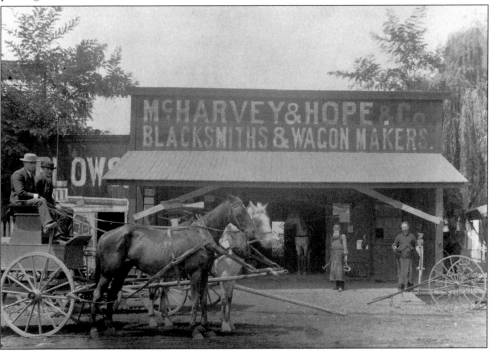

McHarvey & Hope, a blacksmith and wagon maker's shop, was located on First Street West. Co-owner Charles McHarvey left New York to cross the Isthmus of Panama to California in 1854, establishing one of the first blacksmith shops in the valley. McHarvey sold out in 1856, but returned the following year and bought back into the firm, forming a partnership with Valentine Hope, a Pennsylvania carriage maker. Blacksmiths fashioned all sorts of household items and tools, including plows.

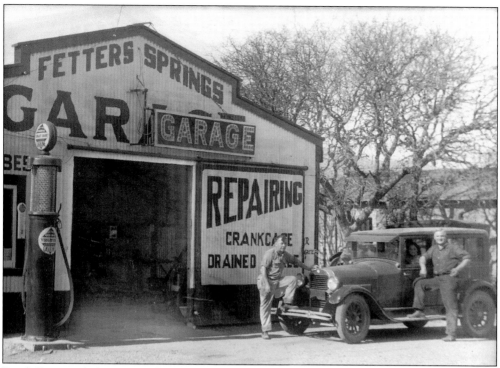

Frank Barnstorf, shown at right in this 1929 or 1930 photo, owned the Fetter Springs Garage. Fetters Springs was named after George Fetters, proprietor of the Fetter Springs Hotel. The other man is unidentified.

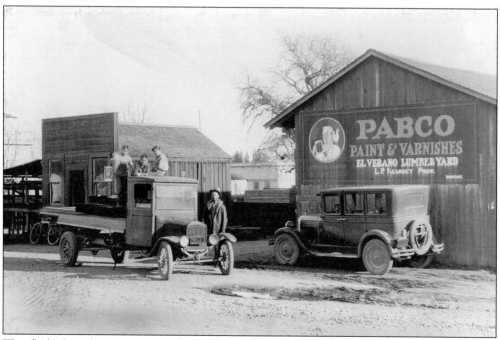

This flatbed truck and car are parked in front of the El Verano Lumber Yard. The lumber yard owner, Louis Kearney, was also a farmer who grew hops and tomatoes.

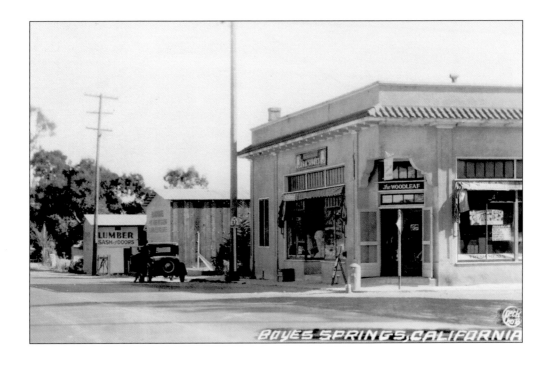

Two different street scenes showing Highway 12 through Boyes Hot Springs in the 1930s are pictured here. The Woodleaf grocery store (above) is now the Big 3 Diner, part of the Sonoma Mission Inn complex. The scene below shows the east side of the highway, looking north. Vallejo Street is just past the telephone pole near the center.

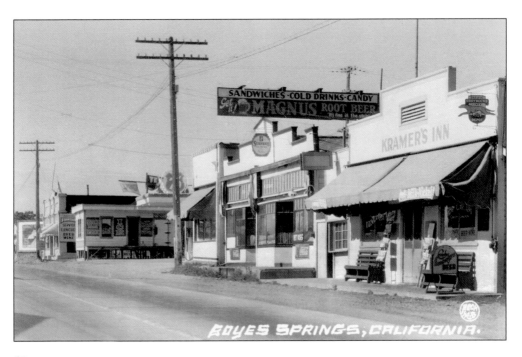

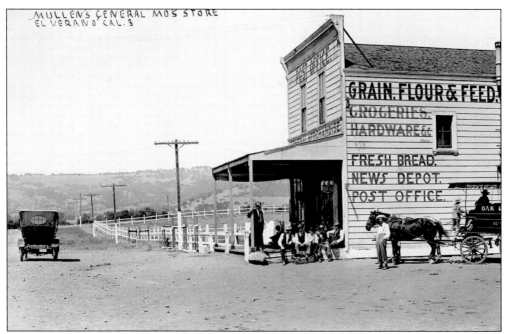

Mullen's general merchandise store in El Verano on Bay and Laurel sold groceries, fresh bread, hardware, and livestock feed and also served as the local post office. The owner, Emmet F. Mullen, was postmaster for 40 years, deputy sheriff for Sonoma County, and station agent for the Southern Pacific Railroad for two decades.

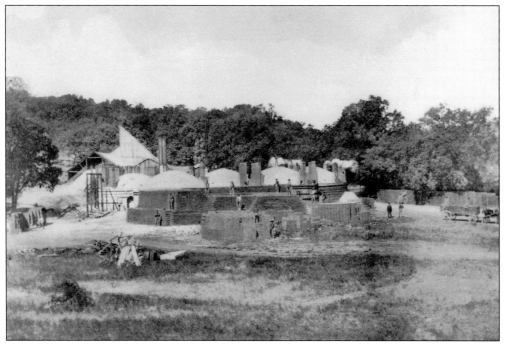

A horse-drawn load of bricks leaves this Glen Ellen Brickyard, established by Joshua Chauvet, in the 1880s. Kilns for drying the bricks can be seen in the background. He used bricks from this yard to build his hotel and other buildings in Glen Ellen.

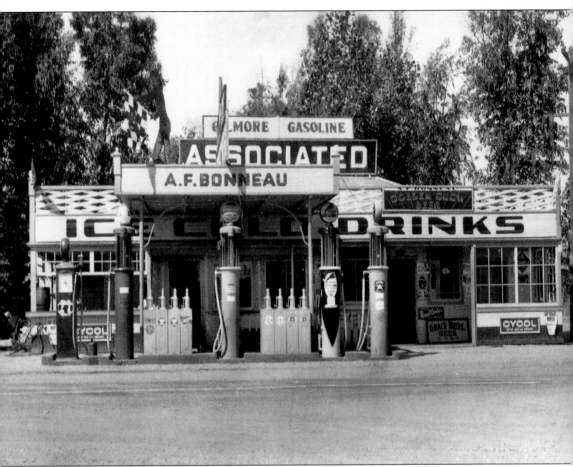

August Bonneau, a native of France, came to the Sonoma Valley in 1922. Seeing the need for a rest stop on the main road into Sonoma from the Schellville area, he and his wife purchased five acres and set up a small store selling soft drinks, groceries, and tobacco. About 1926 Associated Gasoline pumps were added. The Greyhound Bus Company used Bonneau's corner as a transfer stop until a depot was built in Sonoma. This 1930s photograph of Bonneau's looks nothing like the modern Union 76 service station and garage that has taken its place.

Five

VALLEY AGRICULTURE

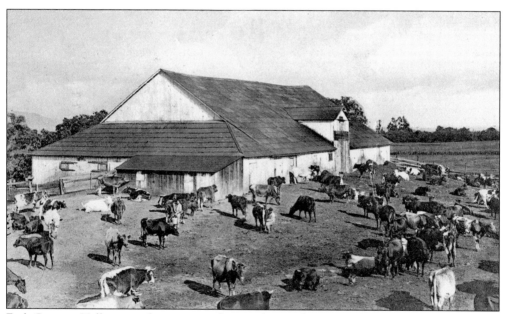

Early Sonoma Valley agriculture was much more diverse than it is today. Dairies once dotted the valley landscape. In this photograph a farmer milks one of his cows while another man to the left holds a milk pail. Easy access to both water and rail transportation enabled valley farmers to sell to distant markets. Although large farm acreage planted in hay, orchards, or grapes existed, most families sustained themselves on small plots of land raising a variety of crops: a few fruit trees, a truck garden, and possibly a small vineyard. Domesticated farm animals supplied meat, milk, and eggs. Following the 1874 phylloxera infestation, which nearly wiped out the wine industry, more fruit trees were planted, including cherries, peaches, apples, pears, figs, olives, prunes, and some citrus. In 1914, for example, sixteen railroad carloads of pears were shipped from the valley to New York. Also in 1914 the Sonoma Valley Union High School sponsored an agricultural and industrial exhibit. Students submitted a wide range of farm produce, and the prize-winning tomatoes received a $10 award from the First National Bank.

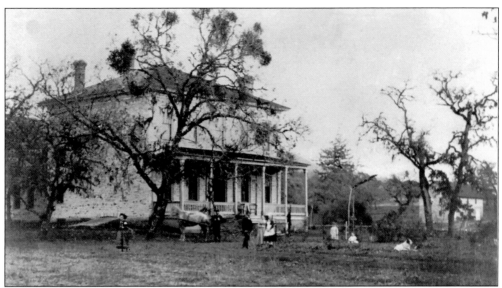

Glen Oaks Ranch in Glen Ellen was established in 1859–1860 by Charles Stuart, who originally came to California in 1849 for gold, but found his fortune in San Francisco real estate. Initially calling his ranch Glen Ellen in honor of his wife, Ellen Mary, Stuart changed the name to Glen Oaks when the neighboring community took the name Glen Ellen. Following her husband's death, Ellen continued to operate the winery, concentrating on white varietals. In the photograph below a farm hand feeds milk cows from a horse-drawn wagon in front of the two-story stone barn on the ranch. In 1994 the house, barn, and surrounding property, described as the "most intact agricultural complex in the Valley of the Moon," was placed on the National Register of Historic Places. Since 2002 the property has been owned by the Sonoma Land Trust, which is dedicated to the preservation of Sonoma County land for future generations.

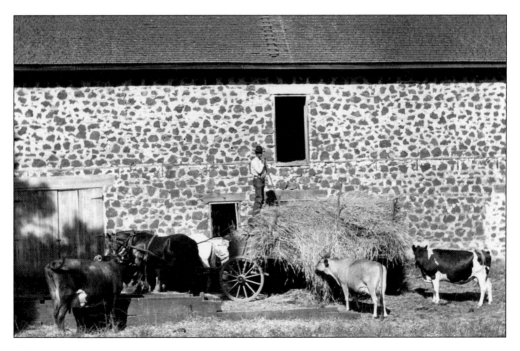

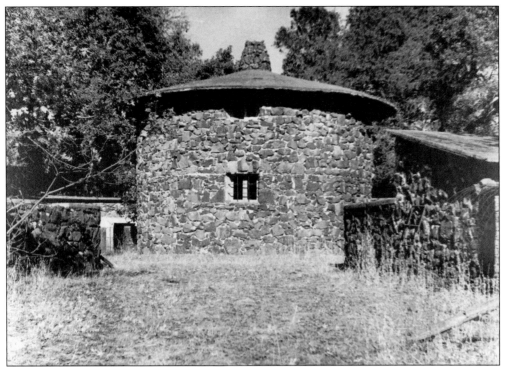

Once he moved to Glen Ellen, best selling author Jack London devoted ten hours a day to running his Beauty Ranch. His interest in scientific farming prompted him to construct this elaborate pig palace, designed in a circle so that one person could manage up to 200 individual pigs.

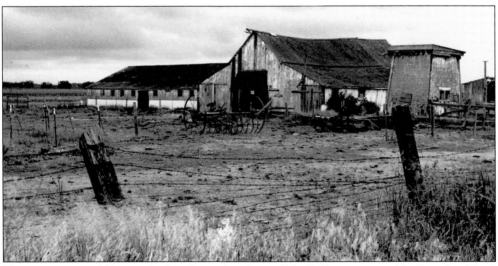

This picturesque old barn, which still stands today in Schellville, was owned by Benedict "Ben" Martin Meyer. A well known local rancher, Meyer owned a small herd of dairy cattle and sold his milk to the Mission Creamery. He was also a rodeo cowboy, entering roping contests during the1940s and 1950s. The community of Schellville was named after Theodore Schell, a rancher and cargo master on boats traveling between here and Sacramento. (Courtesy of Robert Parmelee.)

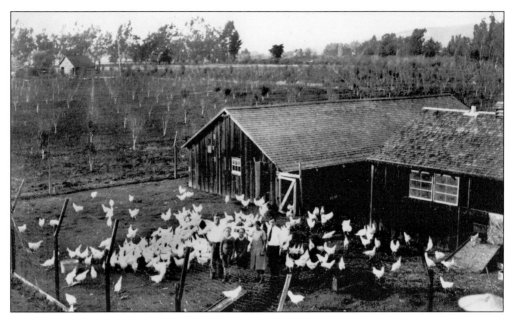

In the early 1990s Jack Tobiason, who lived in the Vineburg area in the 1920s and 1930s, recalled that he helped his mother and brother raise hundreds of chickens. This 1929 Tobiason family photograph shows not only a large chicken house with its residents in front, but a young orchard in the background. The family sold eggs at the Gottenberg Brothers grocery store in Sonoma to supplement their income. The agricultural community of Vineburg, named by John Batto, got its name from the thriving vineyards planted by pioneering families.

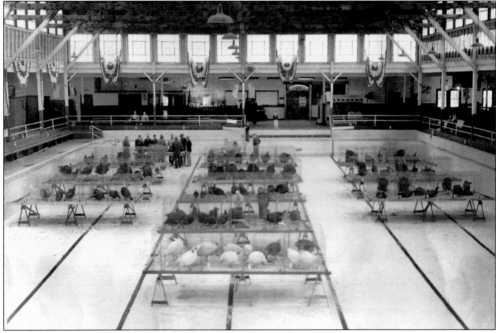

The swimming pool at the Boyes Hot Spring Bathhouse was emptied for the 1946 Western States Turkey Show, sponsored by the Sonoma Valley Chamber of Commerce and the Valley of the Moon Turkey Breeders Association. (Courtesy of Sonoma Chamber of Commerce.)

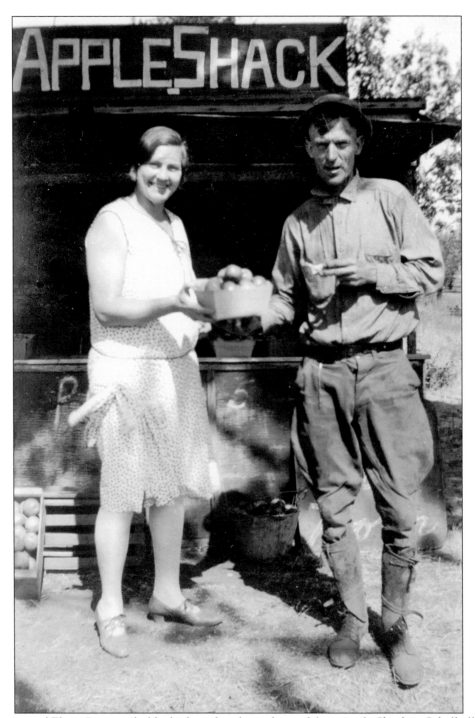

Eunice and Elmer Peterson hold a basket of apples in front of their Apple Shack in Schellville. Apples were only one of a variety of fruit produced in the Sonoma Valley. While some valley fruit was preserved at home or sold at roadside stands like the Apple Shack, tons of fruit were either shipped fresh by boat or train, or dried in the many fruit-processing plants in Vineburg. (Courtesy of Bob and Carol Kiser.)

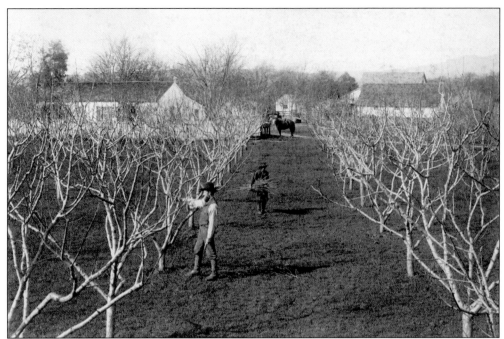

During the 1870s or early 1880s Richard Lidster Watt and helper are busy pruning the peach orchard at River Bank Farm on lower Broadway in Schellville. (Courtesy of Gary Kiser.)

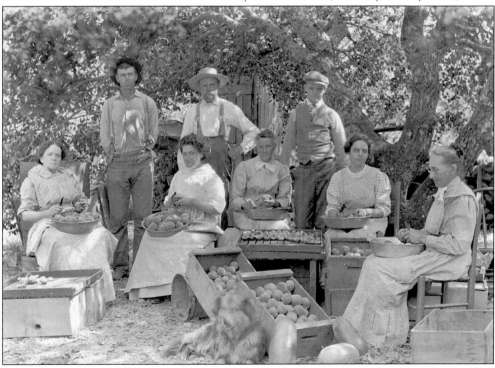

Members and friends of the Quien family prepare peaches for drying at the Glen Oaks Ranch in Glen Ellen. The family purchased the ranch from the Stuarts in February 1896 and lived there for a number of years.

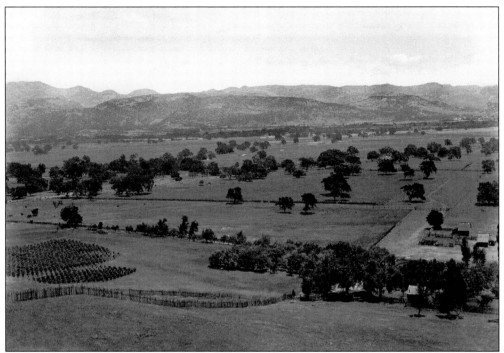

In this 1887 panoramic view from a hill on Caleb Carriger's Ranch in the foothills west of El Verano, one looks northeast across the Sonoma Valley. This view reflects the diversity of the valley's agriculture with grapevines, orchards to the left, orange trees growing near the home and barn, and open pasture land, as well as fields of hay and grain.

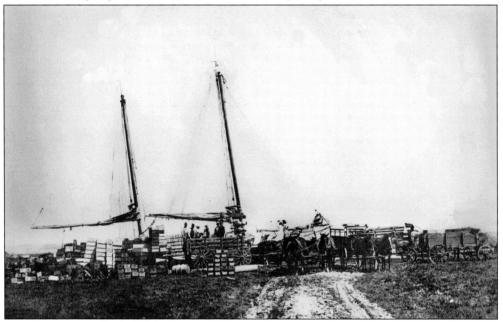

Farmers and ranchers from the Sonoma Valley hauled their produce to various landings along Sonoma Creek where schooners then transported the produce to San Francisco. Pictured here are several horse-drawn wagons and a large number of boxes of fruit being readied for loading.

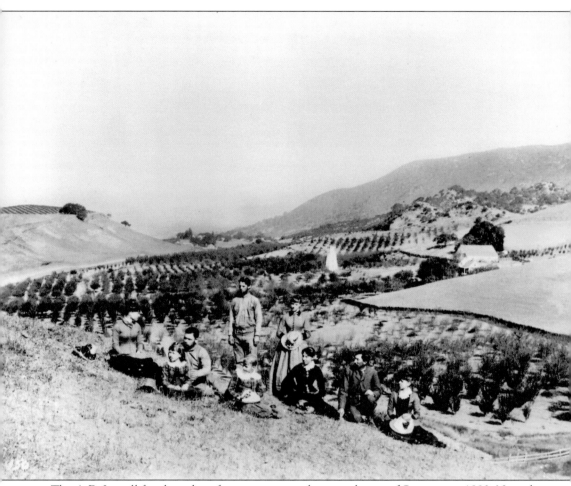

The A.D. Lowell family gathers for an outing on their ranch east of Sonoma, *c.* 1880. Note the ranch buildings and cherry orchards in the background. The Lowell cherry orchard was one of the largest and finest in the Sonoma Valley. The road immediately above the orchard on the left is Napa Road where it intersects with Highway 121 at Stornetta's Dairy.

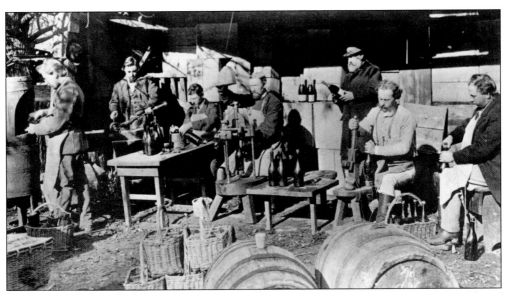

In the 1870s, a number of men are at work in a bottling shed at Buena Vista Winery. Visible are barrels and willow baskets for holding bottles.

This stone structure in Glen Ellen was built for the Chauvet family in 1881 at a cost of $14,000. Today only part of the foundation exists. Joshua Chauvet came to Sonoma in 1856 and with his father, Francois, purchased 500 acres of land and a mill site from General Vallejo. Joshua planted grapes and began making wine as early as 1875. Within five years he was producing 125,000 gallons a year, becoming one of the largest producers in the area.

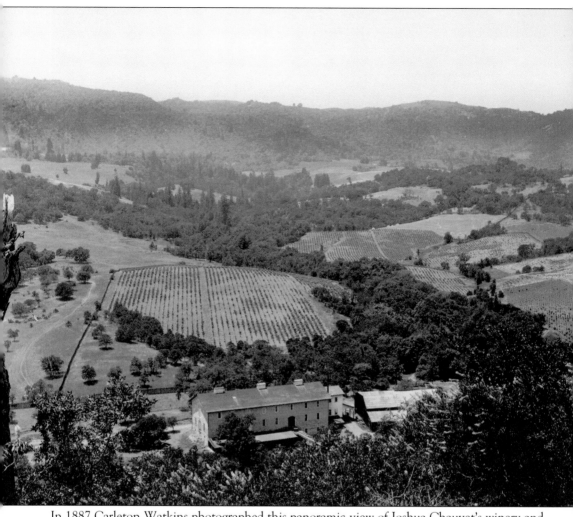

In 1887 Carleton Watkins photographed this panoramic view of Joshua Chauvet's winery and vineyard in Glen Ellen, surrounded by gentle rolling hills covered with native oak trees. The large stone building in the foreground no longer exists. However, the building to the right still exists as part of Jack London Village.

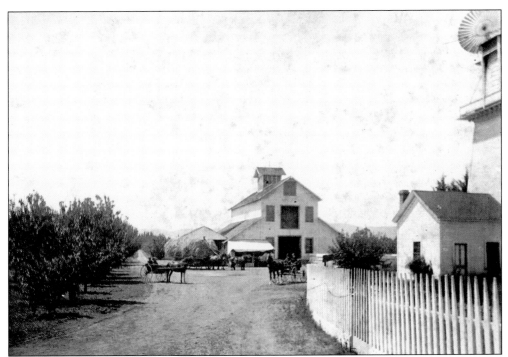

The Robert Hall Ranch was located two miles south of the Sonoma Plaza on Broadway in Schellville. Part of the water tank and the nearby barn are pictured here along with a horse-drawn wagon heavily loaded with hay. In addition to large hay fields, the ranch also had a vineyard and an orchard. In 1914 alone, Hall sold about one hundred tons of peaches. His neighbor and business partner Robert Howe had one of the largest quince orchards in the state. In one month in 1891 he shipped six carloads of quince over the Southern Pacific Railroad. The Hall Ranch below was busy during the haying season, as seen in this view of the hay fields. A Southern Pacific train moves north along the track in the background. (Courtesy of Gary Kiser.)

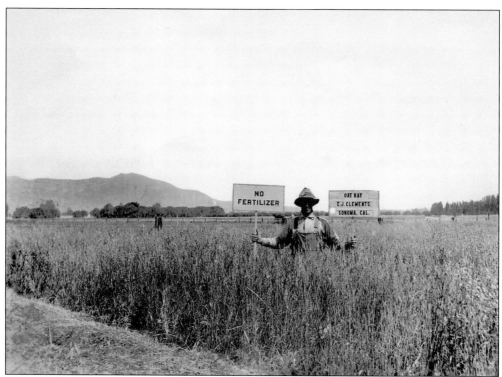

Joe I. Kiser poses in two different oat hay fields owned by E.J. Clements of Schellville. His signs demonstrate the difference in growth in the hay with and without sulphate of ammonia. (Courtesy of Gary Kiser.)

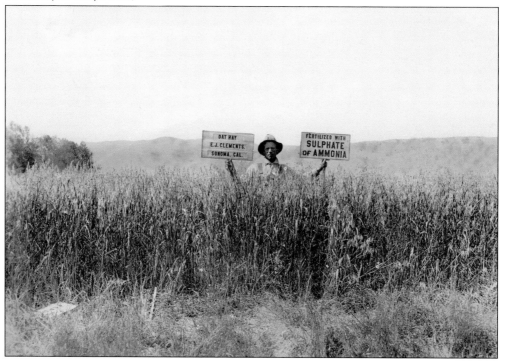

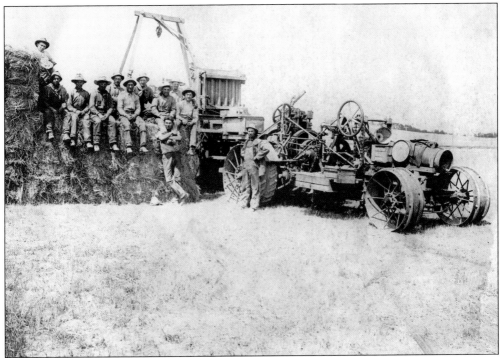

Joe I. Kiser and his 1919 crew pose with the Monarch hay baler nicknamed "The Widow Maker." Pictured, from left to right, are Bill Stoecke, Bill Marble, Ernest Misback, Ted Rorthlin, Thelia Bernensaonie, Adolph Nachbaur, Bill Pierratt, Mig Rainir, Les Carr, and Ferd Kiser. Standing are Hans Mundkowski and Joe Kiser. (Courtesy of Gary Kiser.)

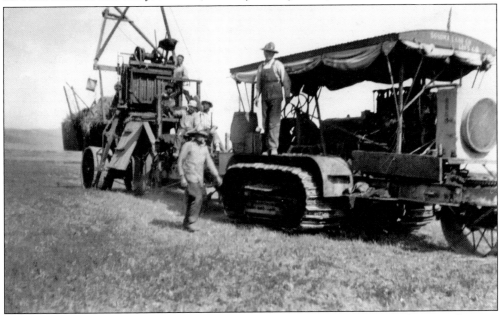

In the early 1920s a haying crew stands on a baler and a tractor, which bears the name Sonoma Land Company. The Sonoma Land Company, owned by Nevada Senator John P. Jones, farmed vast acreage of reclaimed marsh land south of Schellville. (Courtesy of Gary Kiser.)

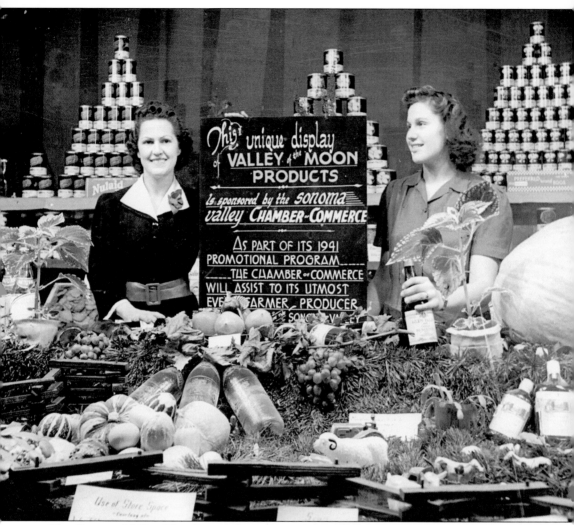

The Sonoma Valley Chamber of Commerce sponsored this display of agricultural products grown or raised in the Valley of the Moon during a 1941 promotional program. Pictured, from left to right, are Dolores Jewett and Donna Maffei Smith. Initially established in 1909, the Chamber of Commerce entered a new era in March 1930 when 32 representatives of the business community gathered for a "get-together" dinner at the Toscano Hotel on Spain Street. Dues were set at $15 a year. (Courtesy of the Sonoma Valley Chamber of Commerce).

Six

EVERYDAY LIFE IN SONOMA VALLEY

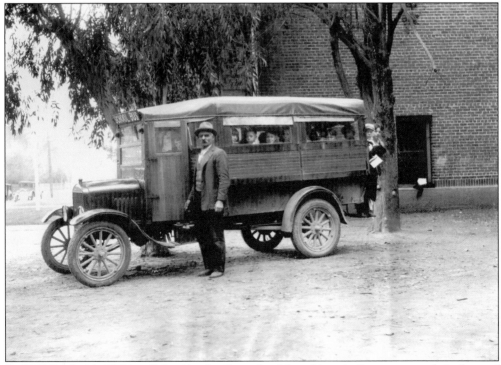

In 1923 Frederick William Schmidt, the first school bus driver in Sonoma, stands in front of the Sonoma Grammar School. This Ford truck was modified to carry students. Schmidt's bus driving days began because his six-year-old daughter Julia was too young to walk the five miles from their home in the hills east of Sonoma to the school site on East Napa Street. Soon his neighbors asked him to drive their children to school as well.

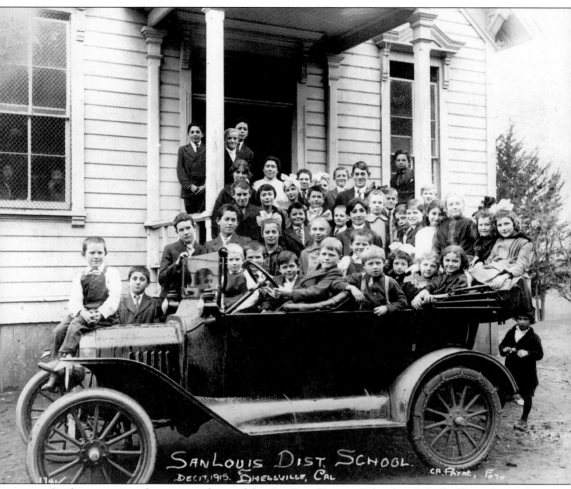

SanLouis Dist School.
DEC 17, 1915. Shellville, Cal
CR. Payne, Foto

Students are seated in a car in front of the San Luis District School in Schellville on December 17, 1915. The first San Luis School, a small one-room building, was established in the early 1880s. It was replaced by this neat, white building on land donated by Robert Howe of Eden Dale Ranch, south of Sonoma. The contract for the construction, estimated at $1,435, was awarded in 1890 to J.C. Bryant. In March 1899 a prankster started a fire under the teacher's desk, and part of the floor and its supports were destroyed despite the efforts of a hastily organized bucket brigade. The fire damage was estimated at $2,500. In 1936 the school was auctioned off and remodeled as a private home. (Courtesy of Gary Kiser.)

In 1910 the entire student body gathers in front of the El Verano School, located on the northwestern corner of Arnold Drive and Verano Avenue. Classes were discontinued when a new school was built on Riverside Drive in El Verano. This former school building is now used by the Church of the Nazarene for classes and social gatherings.

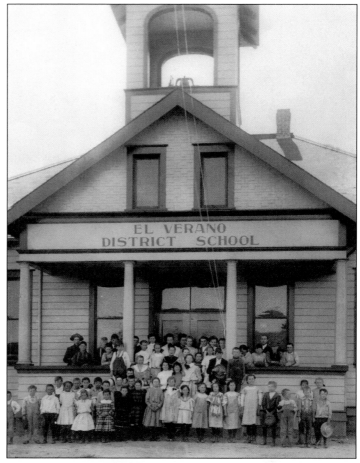

At Christmas, 40 years after the photo at top was taken, a few students, a number of bicycles, and one lone car are pictured in front of the El Verano School. Note Santa and his sleigh on the roof.

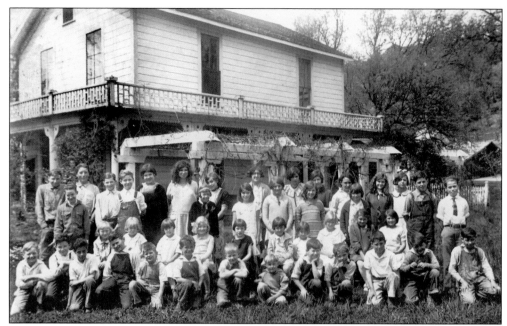

In this 1928 photograph, students gather before "Castle Cozy," in Glen Ellen. This private two-story home, located on O'Donnell Lane and owned by John Cambou, was converted into two classrooms, with one instructor in each room teaching four grades. "Castle Cozy" served as a temporary school after a Halloween prank by a student burned down the Glen Ellen School. The student, who had intended only to fill the classroom with smoke, stuffed empty grain sacks down the chimney. Instead the school burned to the ground. Students transferred from "Castle Cozy" to Dunbar School, with its four classrooms, once it was ready for occupancy in 1930. (Coutesy of Lena Barsi Davis.)

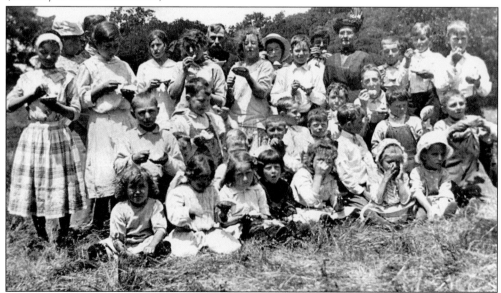

On the last day of school in June 1915, members of Alice Young's class from Watmaugh School enjoy an ice cream picnic. The school, located on Watmaugh Road west of Arnold Drive, was a small 30- by 20-foot structure.

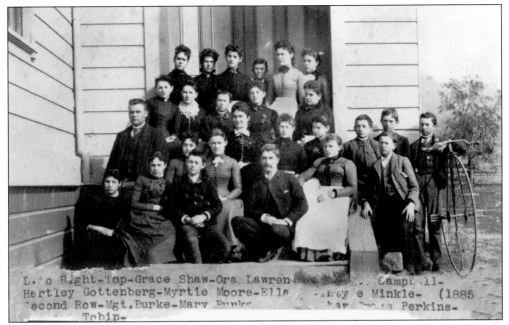

L. to Right-Top-Grace Shaw-Ora Lawren... ... Campb.ll-
Hertley Gottenberg-Myrtie Moore-Ella ...ney e Minkle- (1885
...econd Row-Mgt.Burke-Mary Burke ...ay ... Perkins-
... Tobin-

Students surround their teacher, Lucie Fries (third row, center) in this 1889 photograph. Beginning in 1885, high school classes were held in one room of the Sonoma Grammar School. When the state legislature created high school districts, Sonoma became one of the first 24 areas to have a public high school.

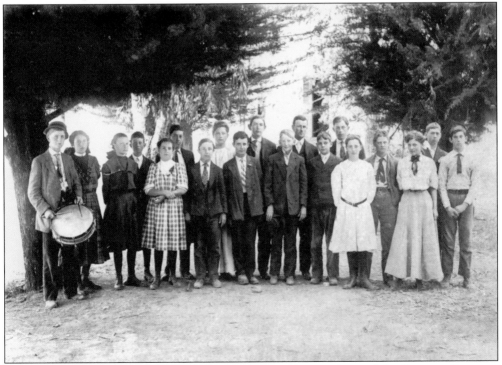

These seventh graders, 19 in all, stand with their teachers in front of the Sonoma Grammar School on East Napa Street in 1910.

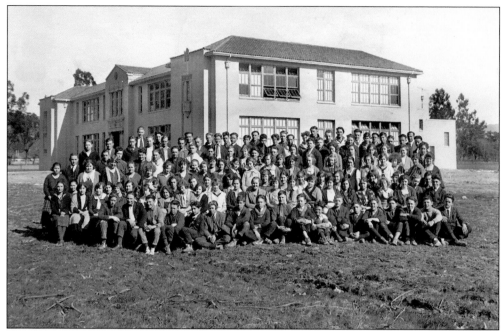

In 1923 the entire student body stands in front of the newly built Sonoma Valley Union High School at its present location on Broadway.

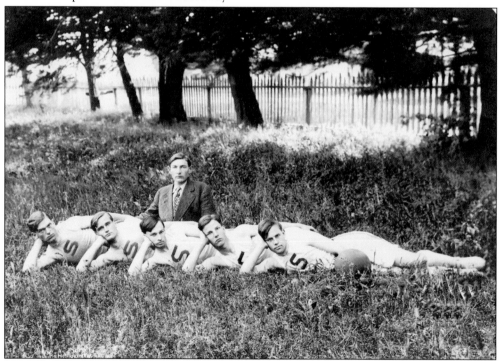

The 1909 Sonoma Valley Union High School basketball team was managed by Reuben Woodworth, shown here wearing a suit. The 1908–1909 season was the school's second year with a basketball team. From left to right are Seymour Trowbridge, Western Logan, Ray Cooper, Otto Dresel, and Ray Poppe.

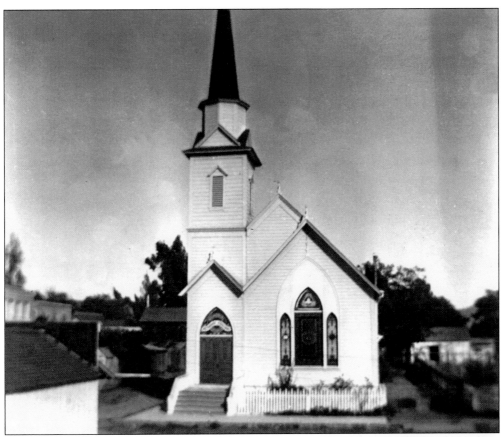

The original three-room Methodist Episcopal Church, dedicated in 1853, was constructed of redwood on the south side of East Napa Street by Rev. James Corwin. From 1857 to 1868 it also served as a public school. In 1893 the sanctuary, moved to its present First Street East location (pictured above), was remodeled and an 80-foot steeple was added. In 1954 the congregation built a new church building on Patten Street, selling this old structure to the First Baptist Church of Sonoma for $1,500.

The First Congregational Church began with the Big Tree Sunday School in 1868. In 1873 a lot on Broadway, across from the present post office, was purchased for $300 and construction of the church (pictured at right) began. To raise money, the lower part of the church was rented to the Grange for their meetings and to the Viticultural Society for displaying choice wines. Since many church members were engaged in the wine industry, there were no objections. In 1960 the sanctuary was moved to its new location on Spain Street. Episcopalians were offered services every other Sunday by a visiting minister at Weyl's Hall.

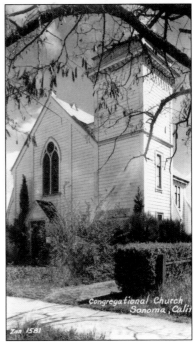

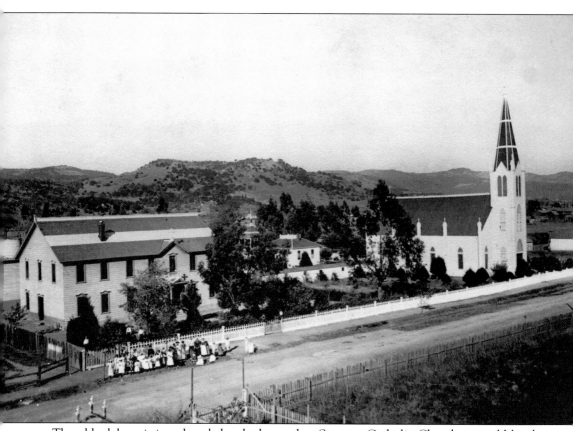

The old adobe mission chapel that had served as Sonoma Catholic Church was sold by the diocese, and a new Catholic Church was built on West Napa Street and Third Street West in 1882. Dedicated to St. Francis Solano, the frame church, pictured here c. 1896, was destroyed by fire in 1896, and again in 1922. It was finally replaced by the present reinforced concrete structure. Students stand in front of the two-story convent, built in 1882, which not only provided housing for the Sisters of the Presentation but also served as a five-room school. The school was closed in 1917, and the convent was remodeled in 1926 for use as a community hall. Sponsored by Mr. and Mrs. Samuel Sebastiani, the hall was remodeled and enlarged, and in 1945 dedicated as the present St. Francis Solano School.

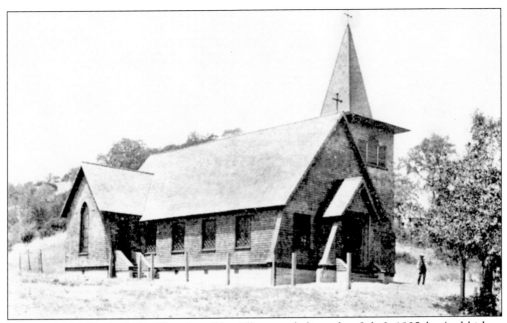

St. Mary's Mission Catholic Church in Glen Ellen was dedicated on July 2, 1905, by Archbishop Montgomery. This church, part of the San Francisco Diocese, functioned as a mission church and was operated by the priests from St. Francis Solano Church in Sonoma. Abandoned in the 1960s following the construction of St. Leo's Church in Agua Caliente, St. Mary's burned down in 1974.

Claire Hope Hyde, seated at a library table, and Leslie Gottenberg Bean pose in the back parlor of the Hope residence on Broadway near Patten Street. The home was built in 1868 by Valentine Hope, a Sonoma wagon maker. Hope, along with Charles McHarvey, founded the McHarvey & Hope wheelwright and blacksmith shop in the 1860s on the west side of the plaza.

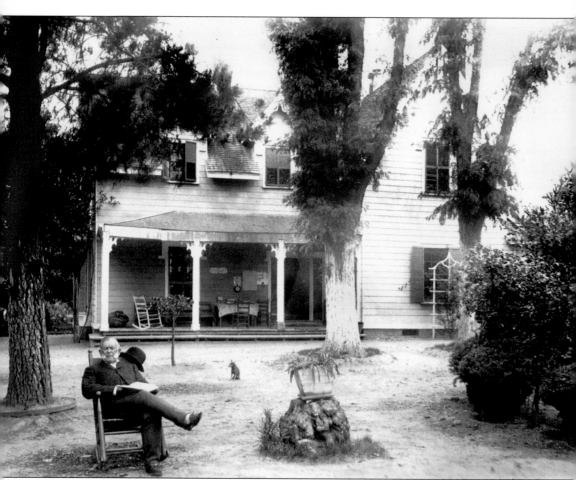

In 1887 General Vallejo relaxes in his rocking chair in front of his Victorian style home, Lachryma Montis. Furnishings and parts of the house, which was built in 1852, came around the Horn to California. Vallejo lived here from 1853 until his death in 1890 at age 82. His daughter Louisa Vallejo Emparan donated the home to the state parks and recreation department in 1933.

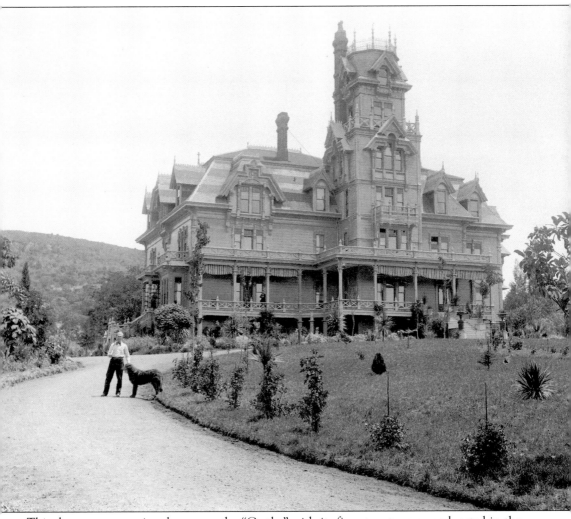

This three-story mansion, known as the "Castle," with its five-story tower, was located in the eastern foothills. In 1880, Robert and Kate Johnson paid $46,501 for the property and built this home shortly after. The estate eventually grew to include 300 acres, with lawns, tropical trees, gardens, a Japanese tea house, and a water garden. One floor of this ornate house was home to Kate Johnson's Persian and angora cats. After her death in 1893, the house passed through several hands, serving as a resort at one point. It was eventually sold to the state and used as a home for delinquent women. In March 1923 the structure burned to the ground.

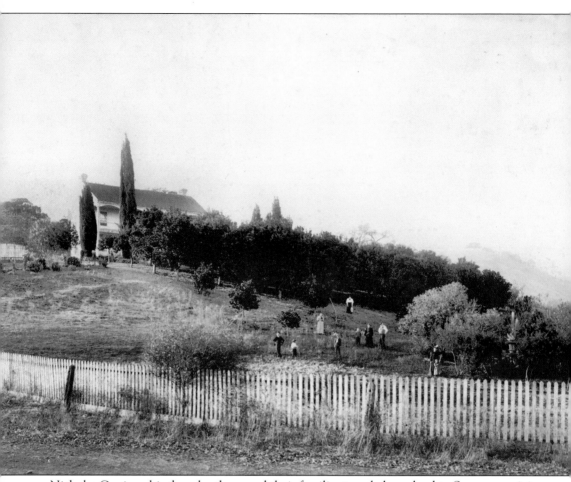

Nicholas Carriger, his three brothers, and their families traveled overland to Sonoma, arriving in 1846. Successful in the gold fields, he purchased 1,000 acres from General Vallejo and in 1849 began to build this Southern-style home in El Verano on a slope overlooking the valley. He planted his vast lands in grapes and fruit trees, and raised dairy cattle. He built a three-story wine cellar, which could hold 180,000 gallons of wine. In 1876 he produced 35,000 gallons of wine, and 5,500 gallons of brandy.

Joe I. Kiser stands between his sons Antone (Tony) on the left and (Little) Joe on the right in front of the family home *c.* 1909. The Kisers ran a dairy and raised pears, apples, cherries, and apricots. This house, still standing, is located on lower Broadway south of Sonoma. (Courtesy of Gary Kiser.)

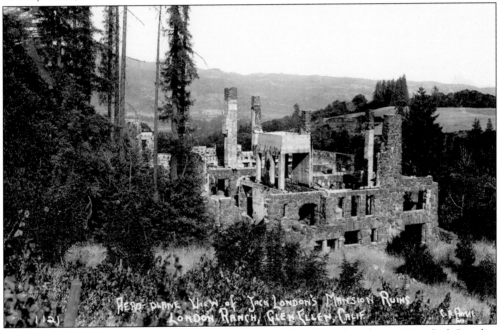

One of the first American writers to earn more than $1 million from his writing, Jack London used an advance from *The Sea Wolf* to make his initial purchase of 129 acres in Glen Ellen, the beginning of his Beauty Ranch. Writing several hours a day, he devoted most of his time to animal husbandry, breeding Shire horses, Jersey cows, and White Leghorn chickens, and practicing scientific farm management. His rustic stone and timber mansion, "Wolf House," pictured here, mysteriously burned down shortly before London and his wife Charmian planned to move in. Although London had enemies because of his political involvements, the most recent evidence suggests that rags soaked in linseed oil, used to treat interior wood, were to blame for the blaze.

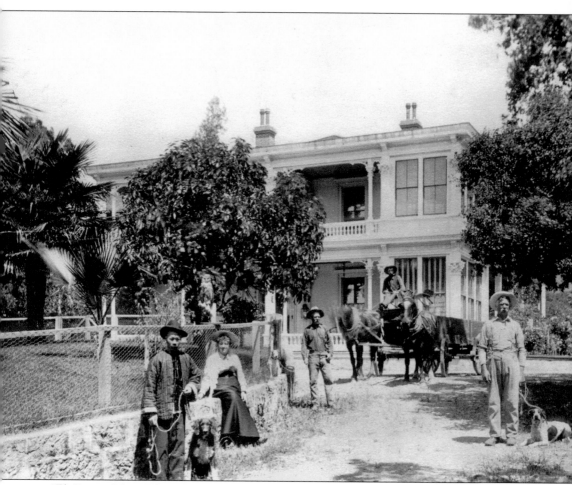

"El Cerrito," located on Seventh Street East, was the gracious home of Jacob R. Snyder and his wife Rachel Sears Snyder. Jacob had served as quartermaster of John Charles Fremont's battalion, was a delegate to the state constitutional convention, and later a successful banker and wealthy vineyard owner. His wines took medals at the Mechanics Fair and at the State Fairs. His three-story stone cellar could hold 300,000 gallons. Jacob died in 1878. His widow, sitting on the rock wall, poses with some of her employees, including June, a Chinese worker, Allie Johnson, Joe Kearney, and Ben Pinder. This property was later sold to A.E. Tower, a wealthy New Yorker.

Seven

GETTING AROUND
THE VALLEY

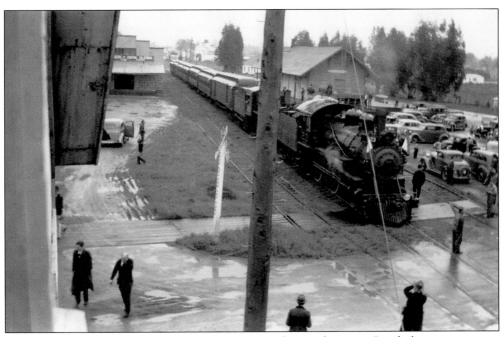

This 1940s photograph shows the Sonoma Depot on the Northwestern Pacific line in its present location. The structure burned in 1976 and was rebuilt and dedicated in 1979 as the Depot Park Museum. The first railroad was the Sonoma Valley Railroad Company, which in 1878 ran a three-foot, narrow-gauge track from Wingo station in the southern part of the valley north to Schellville, then to Vineburg, and finally to Sonoma in 1880. At that time the depot, car barns, engine house, turntable, water tank, and other buildings were located along the north side of the plaza. Within two years the tracks had reached Glen Ellen. In the early 1880s the railroad was purchased by Peter Donahue, owner and builder of the San Francisco & North Pacific Railway Company (later called the Northwestern Pacific) and a standard gauge was installed. Competition came when the Southern Pacific Railroad began running trains to Santa Rosa. This newly enhanced train service enabled the valley to soon become a tourist magnet.

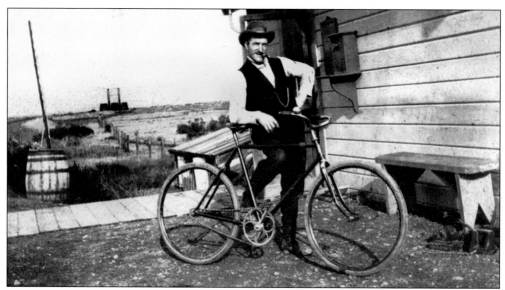

Louis Semino, bridge tender at Wingo on Sonoma Creek from 1902 to 1935, poses with his bicycle in front of the Wingo station. He was on duty 24 hours a day, opening and closing two different bridges, traveling between them on his bicycle. One wooden swing bridge, seen in the background of this photo, crossed Steamboat Slough and allowed Southern Pacific trains coming from the East to cross to Wingo. The other was a steel bascule bridge built in 1921, which allowed the many cargo boats to go back and forth from the Embarcadero, the farthest upstream of the many landing points on the Sonoma Creek. Water craft landed at this site as early as the 1820s.

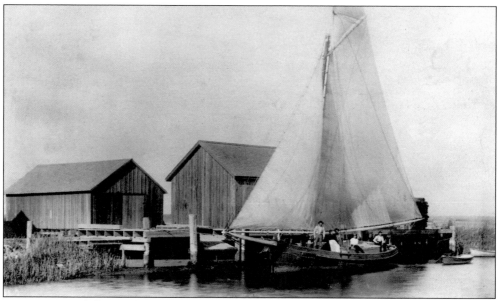

Louis Semino, left, stands in the bow of this sailboat at Hauto landing, which was named for J.P. Hauto, captain of the schooner *Four Sisters*. Hauto made daily trips back and forth between San Francisco carrying wine, table grapes, cherries, hay, grain, cheese, etc. The landing was located on Sonoma Creek, downstream from the end of Millerick Road. (Courtesy of Gary Kiser.)

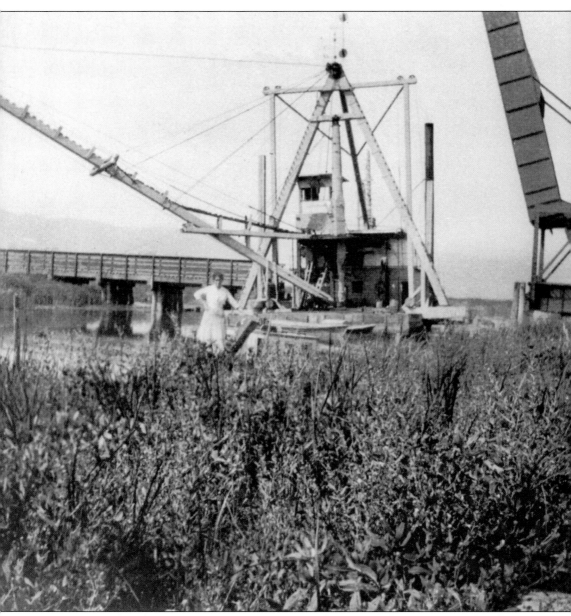

The steam dredge *Nevada* was used to form and maintain the levees along Sonoma Creek south of Schellville. It is shown here in the early 1920s with the new Wingo train bridge in raised position to the right, and Mrs. Louis Semino, wife of the bridge tender, in the foreground. This four-engine dredge, built at the cost of $20,000, "did the work of 1,000 men." Dredging in Sonoma Creek began in the 1860s to reclaim thousands of acres of marsh lands between San Pablo Bay and present day Schellville for dairying and farming. Sonoma Creek, which begins at the upper end of the valley in Kenwood and empties into San Pablo Bay, provided early valley residents with irrigation, recreation, and fishing.

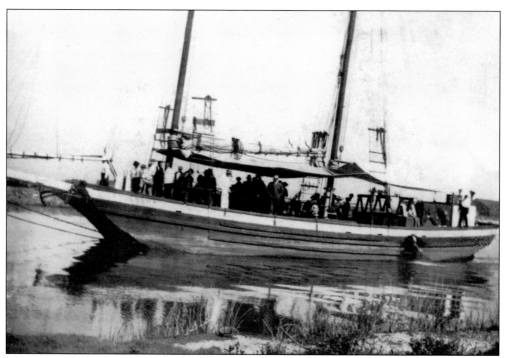

This scow schooner on Sonoma Creek is loaded with passengers. Sloops, scows, and power and sail schooners regularly carried passengers and Sonoma agricultural produce to the Bay Area. The ships were gradually replaced by trains and later automobiles and trucks.

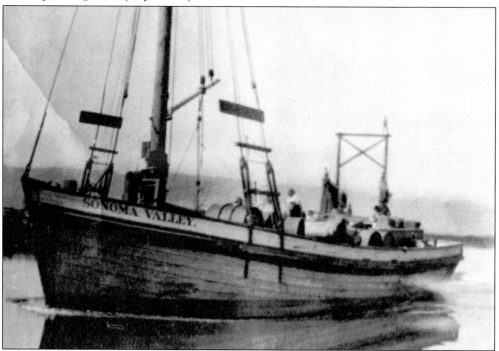

In this c. 1902 photo the *Sonoma Valley*, a sail and power-driven vessel used to carry freight, moves along Sonoma Creek.

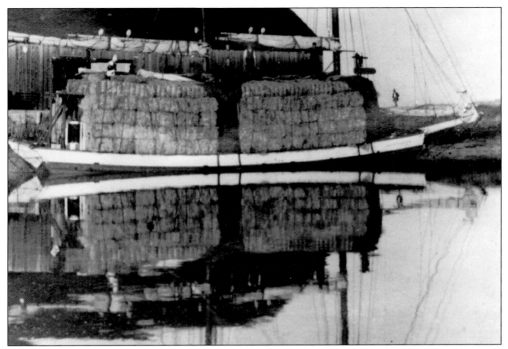

With a warehouse in the background, a schooner loaded with hay is docked at a landing south of Schellville, one of several along Sonoma Creek. Other items moved by small schooners, hay scows, and barges to San Francisco included sacks of grain, table grapes, wine, cheese, firewood, and dressed stones from various quarries, including Shocken Hill.

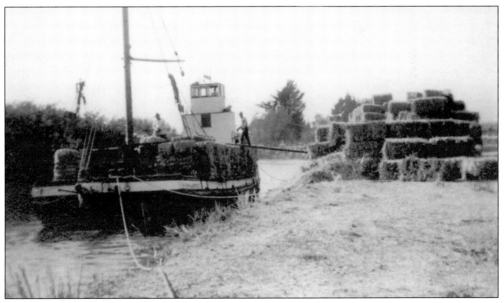

The schooner *Regina* docks on Sonoma Creek at the ranch of Nevada Senator John P. Jones (the Sonoma Land Company). Bailed hay grown in the valley is being loaded for delivery to San Francisco and elsewhere. The extensive Jones ranch had a record harvest in 1921. By August some 16,000 tons of hay had been harvested with a five-man crew bailing 143 tons a day.

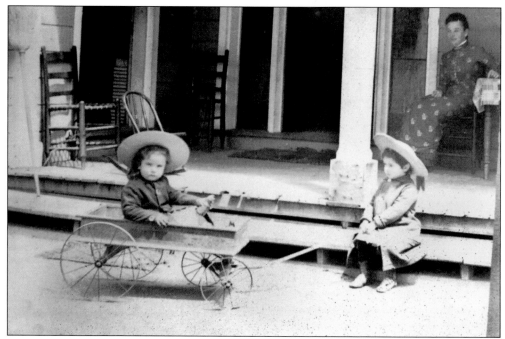

Two of General Vallejo's grandchildren, Raoul and Carlos Emparan, pose in front of the Vallejo home with their toy wagon. The photograph is one of many taken of the Vallejo family, home, and gardens in 1887 by noted photographer Carleton Watkins.

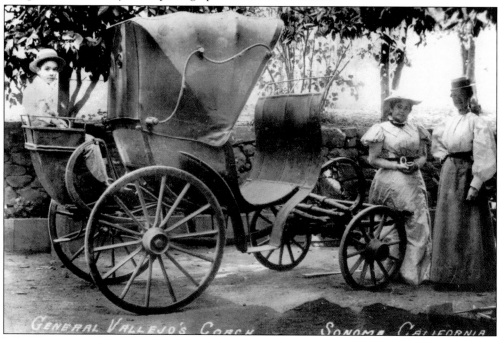

Lulu Emparan and Mabel Lowell stand in front of General Vallejo's coach, "The Waterloo," with Lulu's son Carlos in the rear seat. This coach can be seen in the "chalet," a northern European-style structure that once served as a carriage house, but is now a museum in the Sonoma State Historic Park.

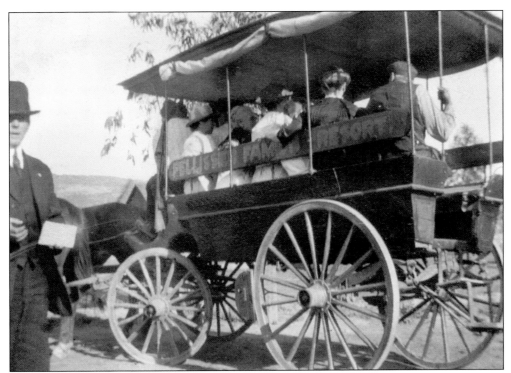

This horse-drawn resort omnibus is ready to leave for Pellissier's Farm Resort (Lawrence Villa), located on Second Street East. Such vehicles transported visitors to and from valley train stations and resorts or other tourist destinations.

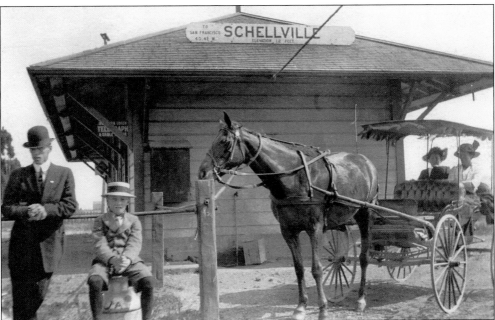

The Kiser family waits beside the Northwestern Pacific Depot in Schellville around 1910. Joe I. Kiser stands next to his son Joe T. Kiser while Mrs. Large and Mrs. Margaret Watt Kiser remain in the wagon. (Courtesy of Gary Kiser.)

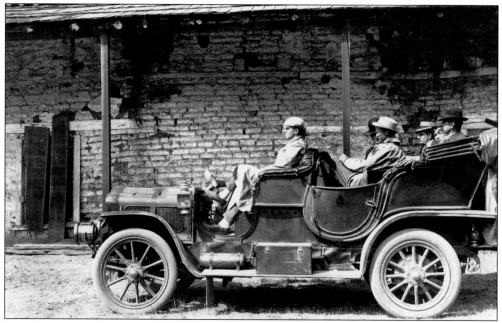

Jack Gottenberg, driving a 1908 White Steam car loaded with passengers, stops in front of the Sonoma Mission.

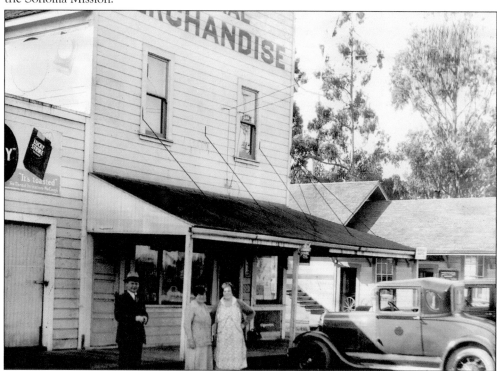

Carloads of fruit were regularly shipped out of the Northwestern Pacific Depot in Vineburg. This 1930 photograph shows the Vineburg Store to the left of the depot at the intersection of Eighth Street East and Napa Road. Bill Helberg, representative of Shell Oil Company, visits with Mrs. Kaboon and Mrs. Rubke.

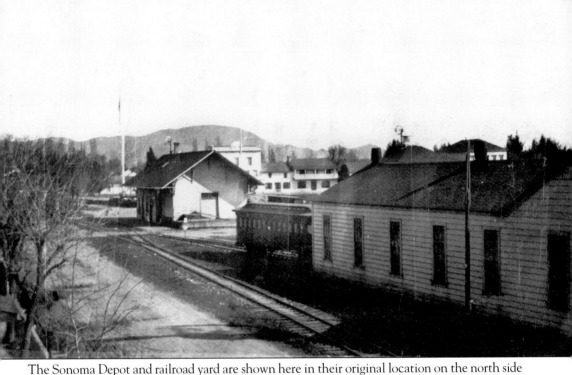

The Sonoma Depot and railroad yard are shown here in their original location on the north side of the plaza. The narrow gauge tracks ran along Eighth Street from Schellville and then turned left on Spain Street to the plaza, west on Spain to Sonoma Creek and then north to Glen Ellen. William Weyl sued the railroad to get the tracks removed from the front of his building (Weyl Hall) and won his case. The railway appealed and stalled but eventually had to move the tracks. The depot was moved in 1890 to its present location in Depot Park.

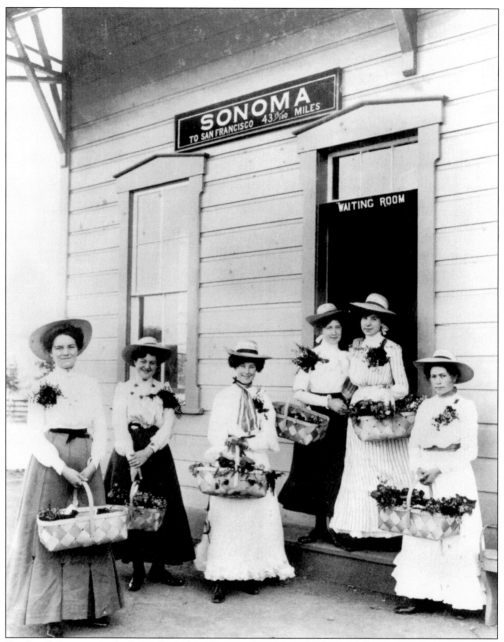

Six local Sonoma girls dressed in their best and carrying baskets of flowers gather outside the Northwestern Pacific Depot in Sonoma. Fourteen-year-old Elvira Eraldi stands at the far right. She later married Samuele Sebastiani and became the mother of Lawrence, Sabina, and August. The morning this photograph was taken, Elvira had been stung on her lip by a bee. The swollen lip is quite visible.

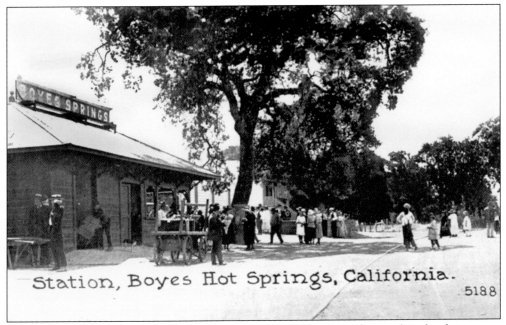

Station, Boyes Hot Springs, California.

5188

The development of the mineral springs in Boyes Hot Springs brought a multitude of visitors to this small valley community. Passengers are seen gathered at the station awaiting the arrival of the Northwestern Pacific train in this c. 1920 photograph.

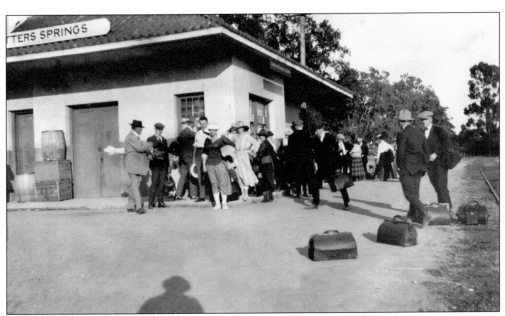

Passengers on this very windy day wait at the railroad station built by Northwestern Pacific Railroad Company in Fetters Springs. The Southern Pacific Railroad also used this station in the 1930s. The building is still standing on Depot Road.

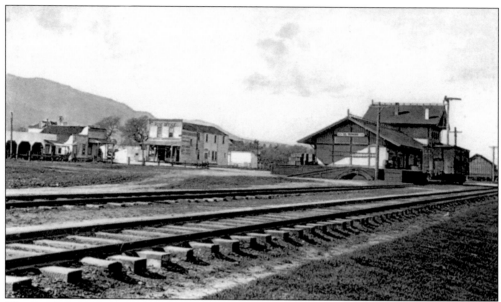

The Southern Pacific Railroad depot in El Verano was built in 1887. A hotel, store, and several homes were soon constructed by the Sonoma Valley Improvement Company, a railroad sub-corporation. Although several trains ran daily, traveling in both directions to serve the small community, El Verano failed to thrive. It was reborn in 1900 and soon became a tourist destination. The track was removed in the mid-1930s.

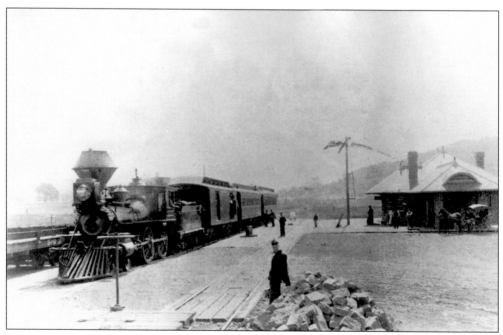

Engine number 1235 stands in front of the Kenwood Depot along with a mail car and two coaches of the Santa Rosa and Carquinez Railroad (later the Southern Pacific). The railroad arrived in Kenwood in the summer of 1888. The depot building, used as a community center, still stands.

Eight

VALLEY RESORTS AND HOTELS

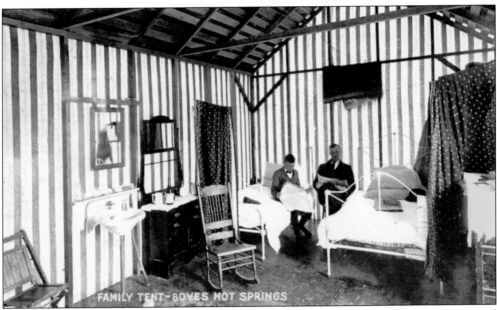

FAMILY TENT–BOYES HOT SPRINGS

To ensure adequate space for the many visitors who came to Sonoma Valley, spacious striped family tents, like this one at Boyes Hot Springs Resort, were built on raised platforms. To promote the recreational potential of the Sonoma Valley, the Northwestern Pacific Railroad began publishing a vacation guide in 1900, listing hotels and resorts along its line from Schellville to Glen Ellen. These brochures praised the valley's warm weather and its fresh local produce. In July 1902 a ten-coach train carrying 540 passengers arrived in the valley. Because there was no space available, even in private homes, many of these visitors were forced to return home on the next train. The 1907 guide promoted fishing, hunting, bathing in the various mineral springs, and dancing. The small community of Vineburg had two listings, one offering French cooking and a second with a dance pavilion. Visitors to the town of Sonoma could bowl, enjoy electric lights in some rooms, and use a telephone. The Southern Pacific Railroad also published resort and hotel information along its railroad line.

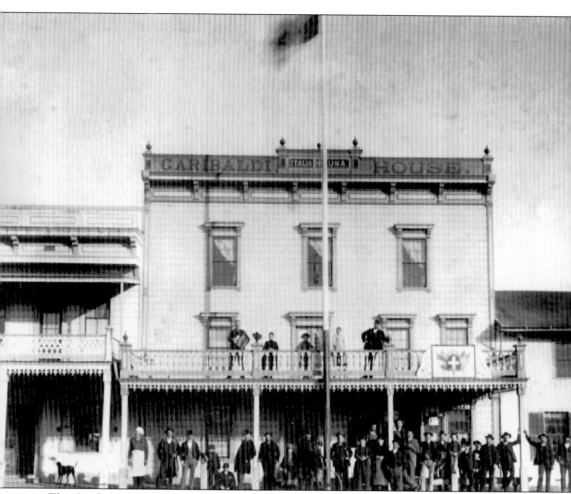

The Garibaldi House (a hotel), located on First Street East opposite the Plaza, was the city's first three-story building. Guests could easily travel the two blocks from the Northwestern Pacific Railroad Depot. The railroad's 1907 promotional literature described the gardens, orchard, and the many hammocks available for the guests' enjoyment. The hotel, then managed by Lorenzo Modini, could accommodate a total of 40 guests with adults paying $5 per week while children stayed for half price. The hotel also offered special rates for families and parties. Prior to the 1911 fire, which consumed the building, it was known as the Bismarck Hotel run by Mrs. Rosa Happa.

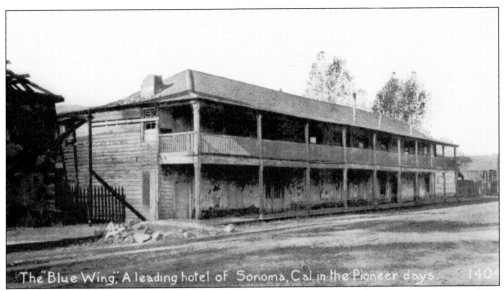

The "Blue Wing". A leading hotel of Sonoma, Cal. in the Pioneer days. 1404

The Blue Wing Inn, located on East Spain Street across from the mission, was one of the first hostelries in Northern California. James Cooper, a seafarer, and Thomas Spriggs, a ship's carpenter, purchased it during the Gold Rush era and enlarged it to operate as a hotel and saloon. Years later it also served as a grocery store. It is now a state historic landmark. Below Sarah Bigelow Flint Cooper Harris and her five children pose for their portrait.

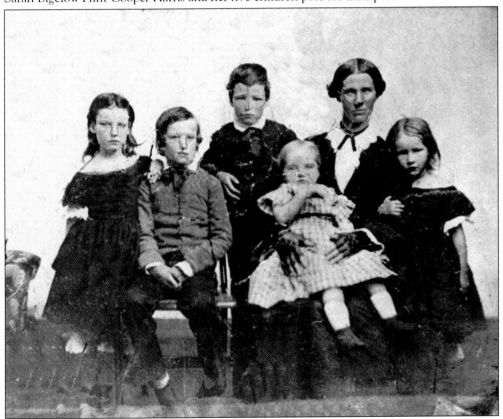

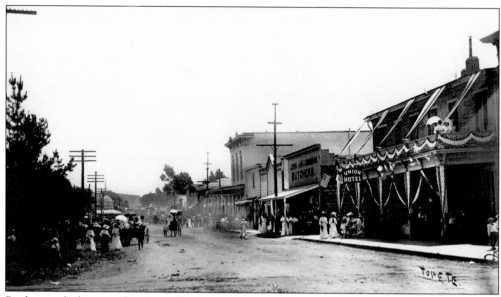

Professional photographer Mike Topete recorded the view shown above of the Union Hotel decorated in ribbons, bunting, and streamers, and the neighboring Lewis and Cummings Butcher shop c. 1908. The Union Hotel, located on the corner of Napa and First Street West, was originally a two-story adobe structure built in 1847 by three former members of Stevenson's regiment of New York volunteers. In 1866 the adjacent livery stable caught fire and the adobe building was destroyed and replaced by John H. Lutgens with the 30-room, two-story hotel pictured here. It was demolished in 1956 to make way for the present Bank of America building. Below, Jimmie Sterling sits in the Union Hotel surrey with the fringe on top, awaiting passengers in this c. 1910 photograph. This bus carried mail and hotel guests back and forth to trains at Sonoma and El Verano Depots.

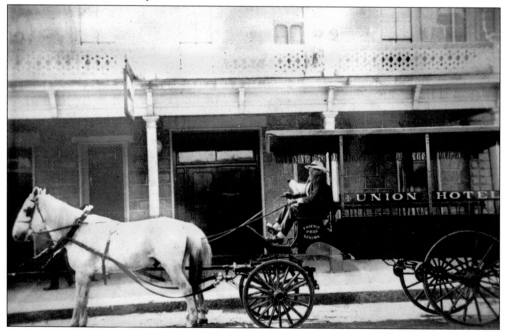

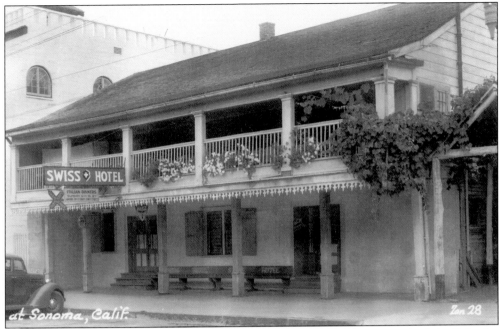

The adobe building now housing the Swiss Hotel on West Spain Street was built by Salvador Vallejo as a home for his new wife, Maria de la Luz Carrillo, Gen. Mariano Vallejo's wife's younger sister. The Swiss Hotel stable, below, is covered with advertisements, including this painting of a horse-drawn sulky, similar to those driven by Joe Ryan.

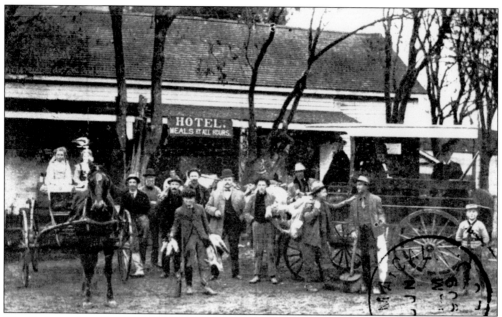

The Embarcadero Resort in Schellville was situated in the "best hunting and fishing grounds in Sonoma Valley." Tony Happe, the proprietor, offered his guests bowling and other games, as well as "meals at all hours."

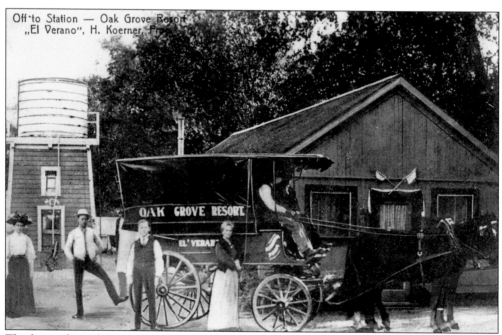

This horse-drawn bus stands in front of the Oak Grove Resort on Petaluma Avenue in El Verano on the Northwestern Pacific Railroad line c. 1900. The busses transported passengers between the various railroad stations and the resorts. Both the Northwestern Pacific and Southern Pacific intensively advertised the resorts along their respective lines.

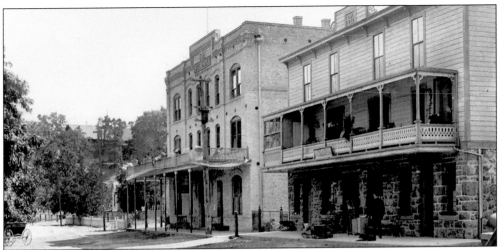

Joshua Chauvet arrived in Glen Ellen in the early 1850s and purchased property from General Vallejo that included a mill on Sonoma Creek. He built a winery, distillery, and this three-story hotel pictured to the left. The hotel, shown here in 1912, was constructed in 1905 of yellow bricks from Chauvet's own brickyard. It still stands in the center of Glen Ellen. A restaurant and bar operated on the first floor while the second floor contained guest rooms. A large dance hall occupied the third floor. The building on the right is the Charles J. Poppe general store and post office. Note the Glen Ellen Grammar School behind the trees on the hill to the far left.

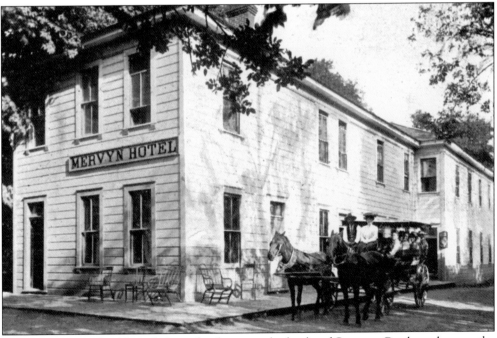

The Mervyn Hotel, 100 yards from the depot on the banks of Sonoma Creek, and across the street from the Chauvet Hotel in Glen Ellen, was in operation as early as 1885. J.T. Peters was the original manager, and through various owners the hotel continued as a favorite dining and dancing spot in the valley. Guests were even offered boat rides in Sonoma Creek and free wagon excursions twice a week to Agua Caliente Springs to enjoy the mineral baths.

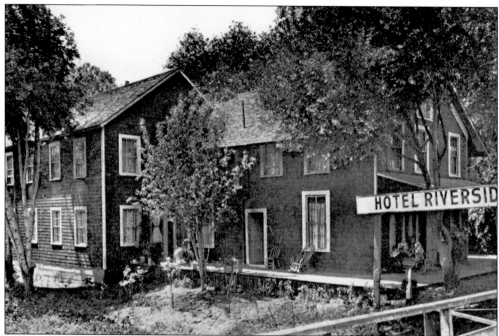

The Riverside Hotel was located only 50 yards from the Northwestern Pacific depot at the point where the Calabazas and Sonoma Creeks converge. In the late 1920s during a particularly severe winter storm, some of the creek bank gave way, leaving two rooms hanging in mid-air. At that time the hotel was being used as a school following a fire that had recently destroyed the Glen Ellen School.

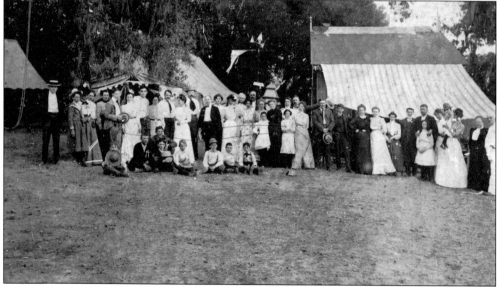

Various family groups enjoy a July 4, 1900, picnic at Los Guilicos Warm Springs. Note the striped sleeping tents. By 1909 this resort, located on Warm Springs Road between Glen Ellen and Kenwood, had a bathing pool, bath house, a pavilion, and 11 cottages for overnight guests. In 1938 the property was sold to Harold and Ethel Morton who operated it as Morton's Warm Springs Resort.

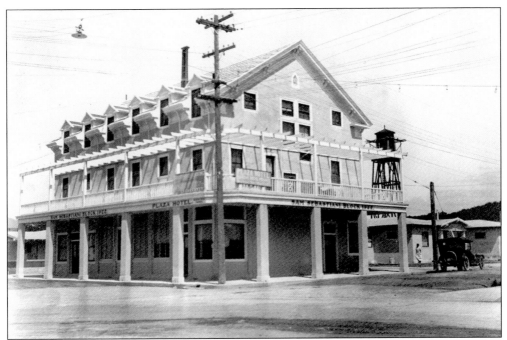

The Sonoma Hotel today occupies the former Plaza Hotel on the northwestern corner of Spain and First Street West. This building, known earlier as Weyl Hall, was built by Henry Weyl in 1879 with a large hall on the second floor where band concerts, dances, and other social events were held. Weyl operated a grocery store on the ground floor. Samuele Sebastiani, who purchased the building in the early 1920s, added the third floor and converted it to a hotel.

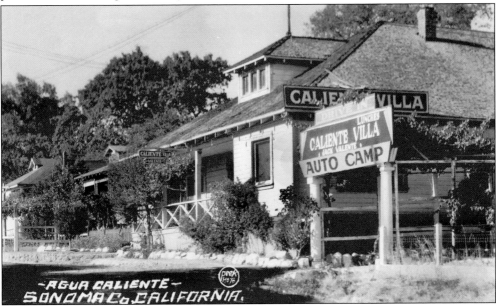

As private automobiles became more common, tourists and hotel guests were no longer limited to travel by train and ferry across San Francisco Bay. Visitors stayed at auto courts much like this Caliente Villa Auto Camp located on Highway 12 in Agua Caliente. Jack Valente was the proprietor.

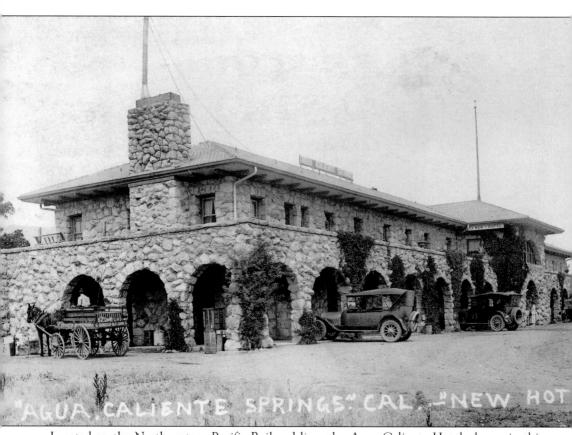

Located on the Northwestern Pacific Railroad line, the Agua Caliente Hotel, shown in this *c.* 1920 photograph, stressed the medicinal properties of the mineral hot springs. The 1925 railroad vacation guide listed hot and cold running water in each room, a "mammoth" swimming tank filled with hot sulphur water, and a solarium. Dancing, tennis, and croquet were also available with a golf course nearby. Today the former hotel, now called Agua Caliente Villa, is a retirement home.

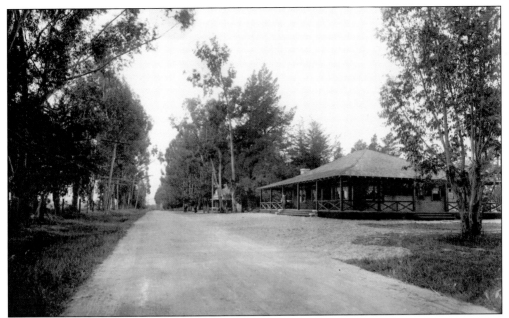

The Sonoma Grove Resort, pictured here in 1911, was located on the banks of Sonoma Creek, near today's Maxwell Village. Guests arrived either by the Tiburon ferry and then the Northwestern Pacific Railroad to the Verano station, or a ferry to Oakland and then a Southern Pacific train to the El Verano station. They had a choice of Italian or French cuisine with plenty of fresh eggs, milk, and fruit, all raised or grown on the premises. Good hunting, fishing, and excellent swimming facilities with three natural mineral hot springs nearby were readily available. Guests could play cricket, croquet, and shuffleboard, or stroll leisurely through the 28 acres of mature shade trees. In 1907 the *Sonoma Valley Expositor* sponsored a contest to decide which of the 28 summer resorts in the valley was the most popular. Sonoma Grove won.

Guests and staff pose before the A. Asplund's summer resort in Kenwood. Note the sleeping tent to the far right. Residents of Oakland could travel by train to Kenwood in only two hours for a one-way fare of $1.35.

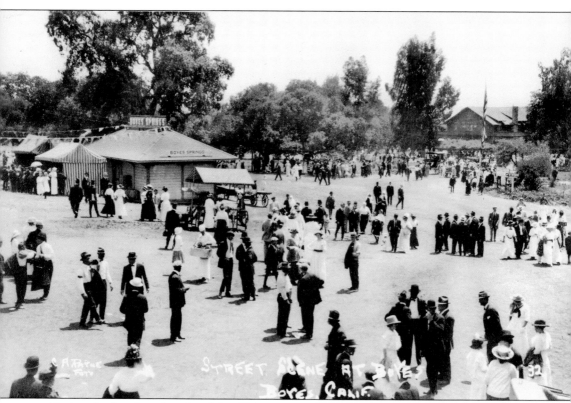

During the first four decades of the 20th century, the area known as the Springs, with its hot mineral springs and bath houses, served as a major center of economic vitality in the valley. This c. 1910 photograph of Boyes Hot Springs train station, at left, and the rustic brick and shingle Boyes Hot Springs Hotel in the upper right, attests to the popularity of just one resort. In the 1918 season, some 70,000 bathers enjoyed the 118 degree Fahrenheit mineral baths. These healing waters were a sure cure for anything from rheumatism to nerve trouble. Unfortunately a spectacular September 1923 fire swept through the Boyes Hot Springs area burning down the clubhouse, the hotel, the railway depot, the cottages, and other businesses and homes. Only the resort's bath house remained. The gas rationing of World War II and the removal of the railroad tracks in 1942 contributed to the decline of the Springs.

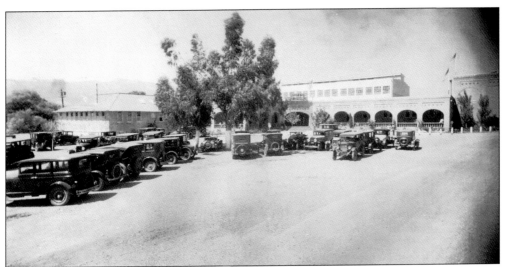

Surviving the 1923 fire, the Boyes Hot Springs Bath House, pictured here c. 1926, held what was billed as the "largest indoor pool in Northern California." Located near Sonoma Creek, the bath house, which was enlarged during the early 1930s, eventually included a roller skating rink, a dance pavilion, and a sun lounge. A modern massage parlor was added in 1936. The bath house burned down in 1969.

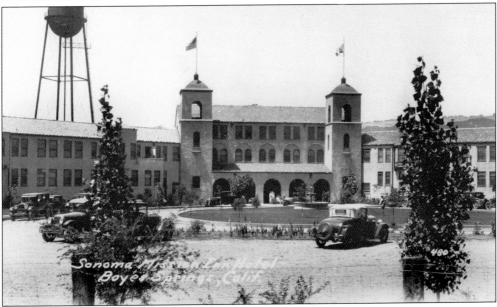

Four years after the fire destroyed the original Boyes Hot Springs Resort, this elaborate hotel was opened in August 1927. Initially called the Boyes Hot Springs Hotel, the name was later changed to the Sonoma Mission Inn, today part of the Fairmont Hotel chain. Each of the original 100 rooms was equipped with steam heat, a sprinkling system, and telephones. An eighteen-hole golf course was built for hotel guests and for use by the Sonoma Golf and Country Club. In 1943 the United States Navy leased the inn for rest and recreation for returning servicemen. Both before and after the war, the mineral baths, hot pools, and saunas were used during spring training by various professional baseball and football teams including the Chicago Cardinals and the San Francisco Seals.

Jean Dutil established the El Verano French Cottages in 1902 and recommended that Bay Area residents get there by taking the ferry to Sausalito and then the train to the El Verano depot. The weekly rate for full room and board was $6 in 1907 and it was open year round, with a daily bus to the hot mineral baths. The cottages were later sold to the Verdier family, who ran it for 40 years before selling it to the flamboyant and eccentric Juanita Musson. "Juanita's" became a regular stop for tourists and residents, a restaurant where chickens and other farm animals roamed freely, until it burned in 1969.

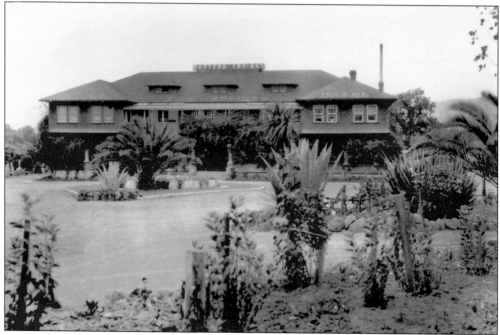

By the 1920s Fetters Hot Springs Resort, located on the Northwestern Pacific Railroad line, included 100 acres of orchards and gardens. The hotel had steam heat throughout the building. To accommodate the large numbers that flocked to the springs during the summer, additional rooms were located in various cottages and tent cabins. The resort had a large concrete swimming tank, bowling alleys, tennis and croquet courts, and offered dancing, theater, and motion pictures in the afternoon and evening.

Nine

FUN AND RECREATION

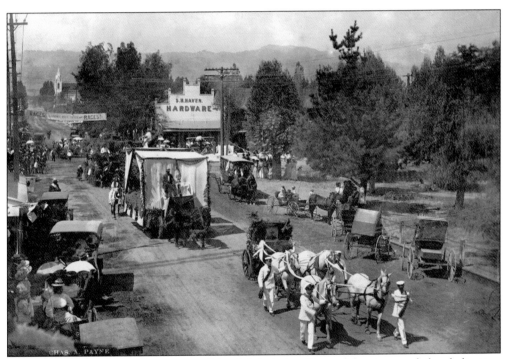

On September 9, 1908, Sonoma combined Admission Day celebrations and the dedication of the new City Hall into one large ceremony, which included a flag raising and the parade pictured below. The parade honored the memory of General Vallejo: his portrait, surrounded by white flowers and greenery, rode in his old carriage pulled by four white horses in a place of honor. Two of General Vallejo's grandsons, Carlos and Raoul, led the team. Various valley resorts and organizations entered decorated vehicles. St. Francis Solano Catholic Church can be seen at top left as the procession heads east along Napa Street. The plaza is to the right. Note the banner across West Napa Street advertising racing at the Sonoma Race Track.

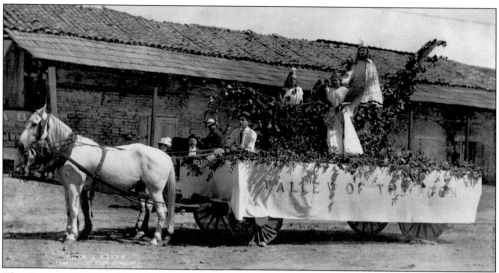

The Sonoma Valley Union High School float, part of the September 9, 1908 Admission Day parade, stops in front of the former mission. Valley residents loved parades, holding them for various occasions including Admission Day, the Fourth of July, and as part of the Millerick rodeo weekend.

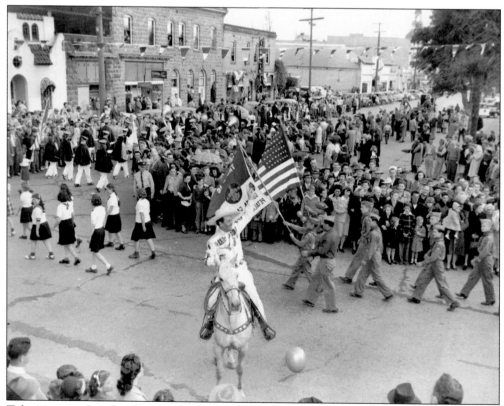

Television star Leo Carrillo, astride his horse, waves to the crowd on Spain Street while parade participants march past him down First Street East during the June 1946 celebration of the Bear Flag Centennial. The Sonoma Plaza is on the right. (Courtesy of June Picetti Sheppard.)

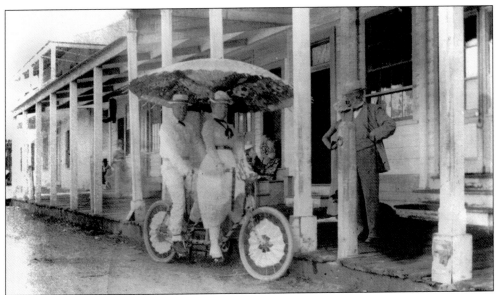

Harriet Gaines with George Breitenbach, owner of the harness shop on the plaza, pose in front of the Poppe building on First Street East after winning first prize on their bicycle built for two at the July 4, 1900, parade. Five years later they married.

This decorated car, a Native Sons of the Golden West parade entry, is parked in front of the Topete Photo Studio near the intersection of Napa Street and First Street West. Mike Topete, who had a studio in San Francisco, came to Sonoma as a refugee of the 1906 earthquake. His work here included many photographs of events in the city of Sonoma as well as school photographs and portraits. He remained in town until 1915.

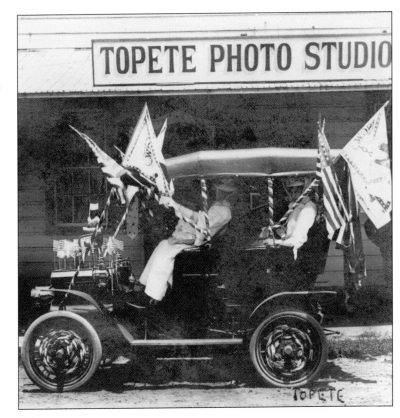

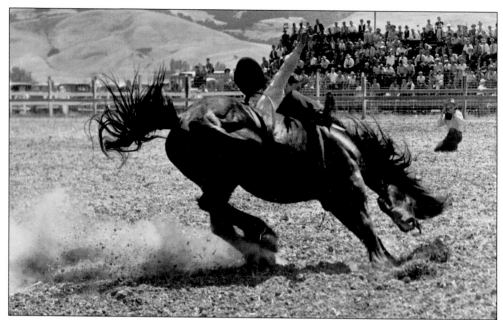

This saddle bronc rider fights to keep his seat in this rodeo event sponsored by the Millerick family. Michael J. and Catherine Millerick's Circle M Ranch was located in Schellville. From 1929 to 1951 the family sponsored a rodeo in the Sonoma Valley—the longest consecutive run of any California rodeo until the Cow Palace was established. The Sunday event was preceded by a parade and street dance. In 1943 the rodeo grossed $4,700 for the Sonoma unit of the American Women's Voluntary Service. It was not unusual to have crowds of up to 8,000 pack the rodeo grounds. (Courtesy of the Sonoma Valley Chamber of Commerce.)

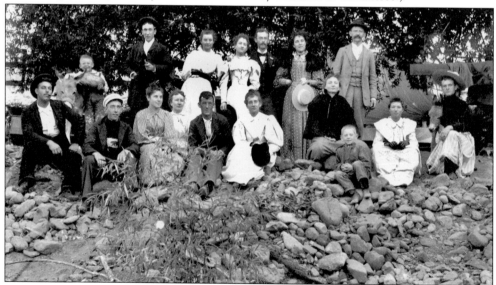

Note the donkeys on either side of this gathering at the Hotz Family camp on Sonoma Creek in Glen Ellen, c. 1896. In honor of the 50th anniversary of the Bear Flag Revolt, the young man, second from the left, wears a replica of the Bear Flag on his shirt. Among those pictured are members of the Hotz family and friends who attended Sonoma Valley High School in the early 1890s.

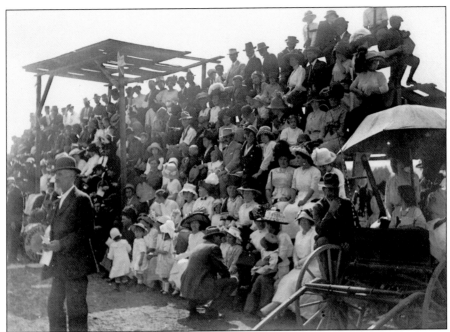

A crowd fills the bleachers in this 1912 photograph at Joe Ryan's race track. The oval track was between First and Second Streets West near present day MacArthur Street. Cheering crowds watched mostly harness racing. Once Ryan's famous pacer, "Jim Chase," raced an automobile and won. Harness racing was discontinued around 1915. The high school then used the track as an athletic field for physical education classes. Joe Ryan and his mother originally moved to Sonoma, where she operated a hotel, about 1886. He worked at the Union Livery Stable at the corner of Napa Street and First Street West, eventually buying it. In 1900 he built the popular Sonoma Race Track where he raced many of his fine horses, pictured below. Appointed in 1901 as a deputy sheriff of Sonoma County, he became sheriff in 1925, but died the following year.

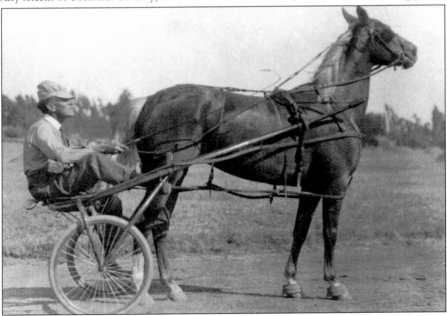

This single lane bowling alley was located at the rear of a saloon between the barracks and the mission. By 1891 it had been removed so that First Street East could be extended to the north.

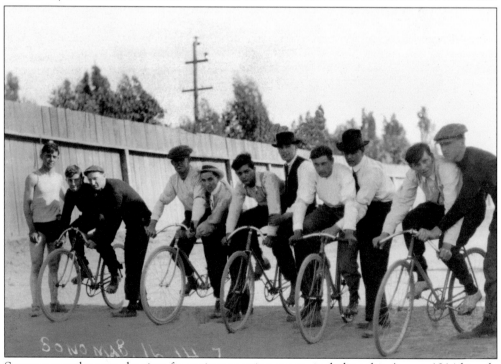

Summer months were the time for various sporting events including this August 1914 bicycle race held at Joe Ryan's Sonoma Race Track.

A group of young women enjoy a watermelon feast during a hot summer day in the valley.

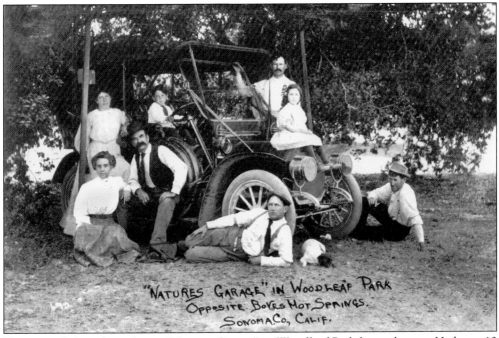

"NATURES GARAGE" IN WOODLEAF PARK
OPPOSITE BOYES HOT SPRINGS.
SONOMA CO, CALIF.

Visitors and their dog relax in "Natures Garage" in Woodleaf Park located across Highway 12 from the Boyes Hot Springs Resort, now the Sonoma Mission Inn.

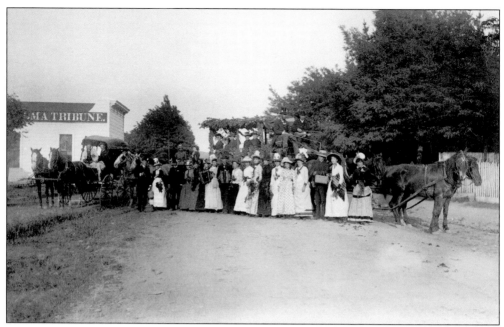

Elegantly dressed men and women gather on East Napa Street for a special occasion in the early 1880s. The horse-drawn wagon on the right is gaily decorated and one of the passengers is holding a violin. Others in the crowd have accordions and picnic baskets. Note the office of the *Sonoma Tribune* to the left, the precursor of the *Sonoma Index-Tribune*.

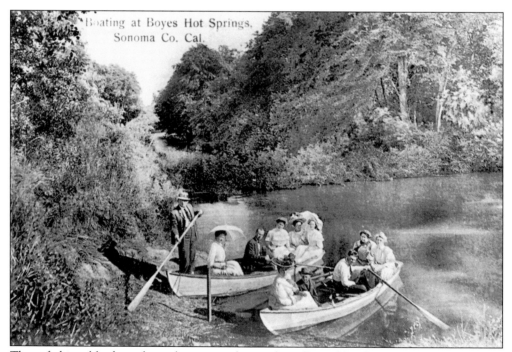

These fashionably dressed couples enjoy a boat ride at Boyes Hot Springs on Sonoma Creek around 1900. Their boats are in a pool created for the summer season, one of a number of such pools along the creek.

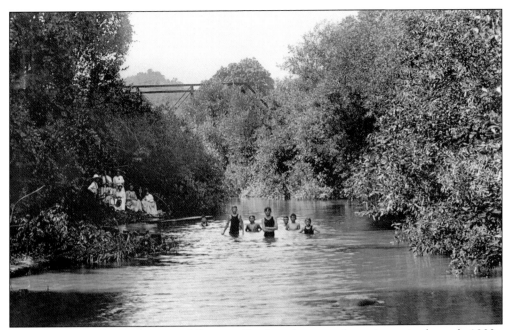

These kids enjoy the cool waters of Sonoma Creek as they pose for a picture in the early 1900s, closely watched by a group of women from shore. Many local children learned to swim in this pool below the old steel bridge in downtown Glen Ellen.

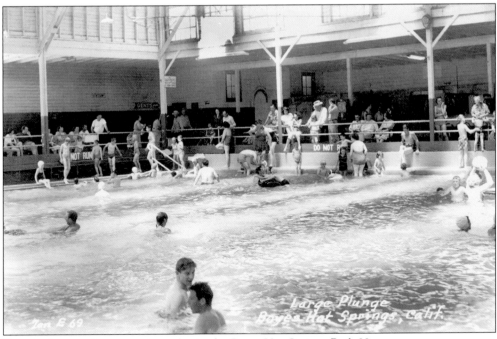

Decades later, swimmers enjoy a day in the Boyes Hot Springs Bath House.

Pony rides were always popular with children. Lloyd S. Simmons, local pharmacist, photographed his granddaughter, Mabelle Dodge, with friends in the 1930s. From left to right are Margaret Andrieux Meyer, Bette Garrison Garric, Charles Groskopf, Jes Thomsen, Maxine States MacArthur, Rene Prestwood, and Mabelle Dodge Heald.

Students of Miss Tamara Lawb's ballet school show off their costumes on the steps of the Sonoma Grammar School in June 1921.

It was common practice for vacationing visitors to have photographs taken and made into postcards to send to friends and families. In this 1910 photograph, a group of people gather around the man in the moon, a play on the Valley of the Moon. According to local legend, early Indian inhabitants claimed that they could see the moon rise seven times over the ridges of the various mountain ranges on the eastern rim of the valley.

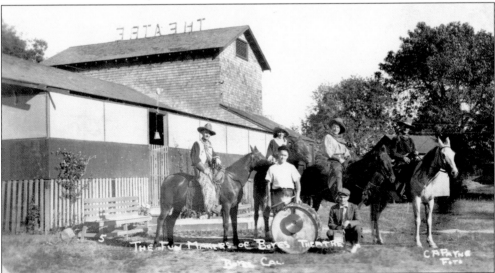

This postcard of the Boyes Hot Springs Theater, sent to a resident of San Francisco in 1915, shows "Fun Makers" playing at a theater on the grounds of the Boyes Hot Springs Resort. (Courtesy of Robert Parmelee.)

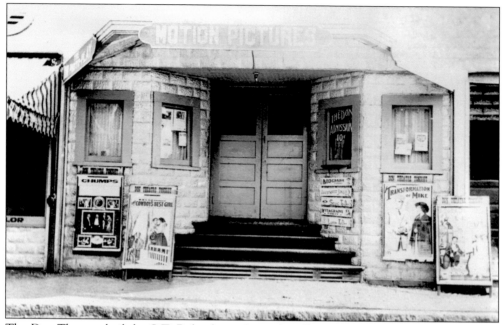

The Don Theatre, built by C.T. Ryland, was located on East Napa Street behind the Mission Hardware Company in the Duhring Building. In October 1913 Sonomans gathered here to attend a lecture, illustrated by moving pictures and stereopticon slides, to promote the purchase of locally manufactured items. By 1931 the theater had installed a full sound system to facilitate the "talkies," and movies starring Walter Houston, Pat O'Brien, and Greta Garbo were advertised. In 1932 the theatre burned down.

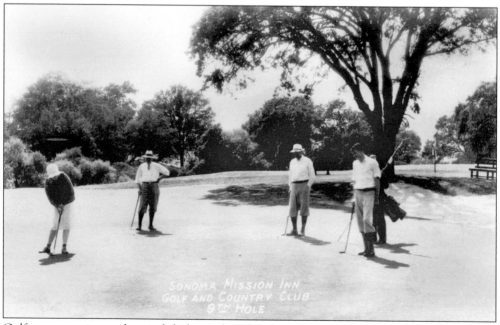

Golfers are putting at the ninth hole on the 18-hole golf course at Sonoma Mission Inn Golf and Country Club in Boyes Hot Springs.

Ten

CIVIC AND
SOCIAL AFFAIRS

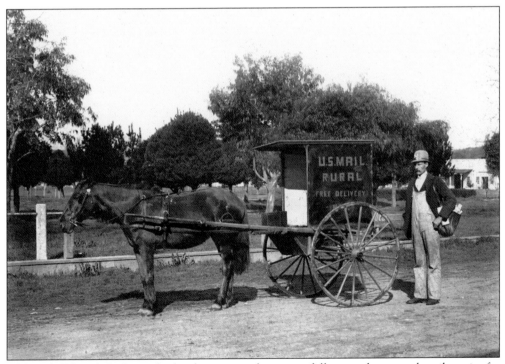

Although Edward G. Guyot had only one arm, he successfully served as a rural mail carrier for Schellville and Vineburg and the east side of Sonoma Valley from 1901 to 1916. Guyot, with a full bag of mail over his shoulder, stands beside his horse-drawn cart in May 1901.

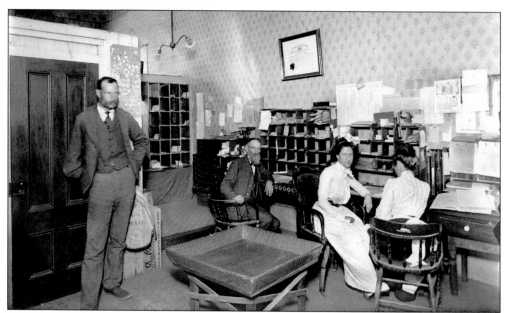

In 1903 mail carrier Edward G. Guyot stands in front of the door in this interior shot of the Sonoma post office, located on East Napa and First Street East. Also pictured, from left to right, are John M. Cheney (the postmaster), Clara Johnson, and Kate McDonnell.

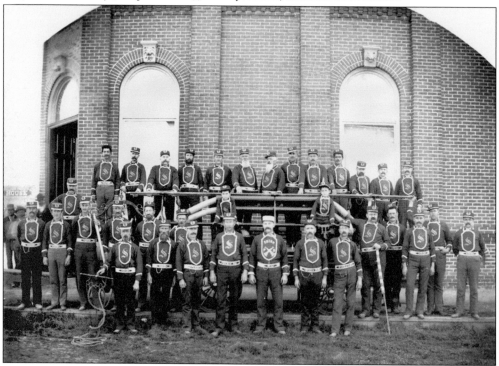

Sonoma Volunteer Hook and Ladder Company poses with its fire-fighting equipment in front of the Sonoma Valley Bank on the corner of Broadway and East Napa Street on March 26, 1892. They are wearing red and white uniforms, which they purchased with nominal help from the city.

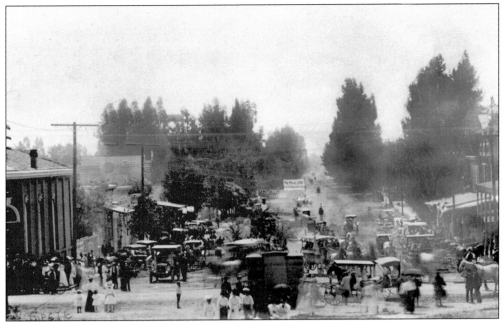

A mixture of automobiles and horse-drawn wagons converges on Broadway at the plaza in Sonoma during a gathering sponsored by the Native Sons of the Golden West (note the NSGW sign hanging on a wire). The large fountain located in the foreground of the plaza was a gift to the city from the Sonoma Valley Woman's Club. Since the brick Sonoma Valley Bank on the left is only one story, this photograph was taken after the 1906 earthquake that damaged the second floor, requiring its removal.

In 1887, Carleton Watkins photographed this panoramic view of the valley, south of El Verano, showing a diverse landscape.

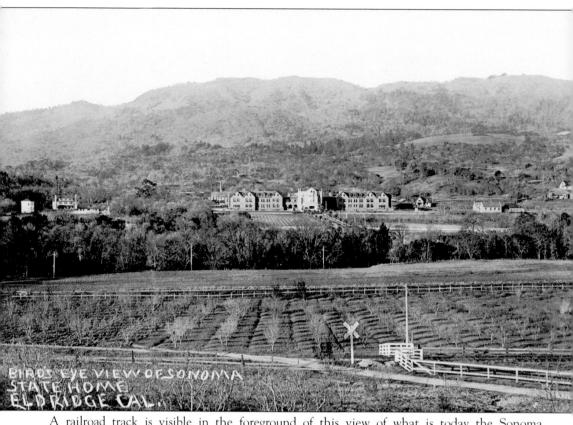

BIRD'S EYE VIEW OF SONOMA
STATE HOME
ELDRIDGE CAL.

A railroad track is visible in the foreground of this view of what is today the Sonoma Developmental Center in Eldridge. The area was named for Captain Oliver Eldridge who served on the site selection committee for the facility, which was established in 1889 on 1,670 acres purchased from William McPherson Hill for $51,000. A farm residence on the property was used to house the first patients, almost 150 children from Santa Clara, who arrived in November 1891. By 1896 some 450 residents called this home. And as the population grew, so did the land; by early 1900 it included 28,000 acres, which enabled the hospital to become almost self sufficient. A complete dairy with milking stalls and pasteurizing plant furnished all of the dairy products, the adjacent hog ranch provided meat, and chickens were raised for eggs. In addition the orchards produced apples, peaches, plums, pears, cherries, and apricots, all dried or canned on premises.

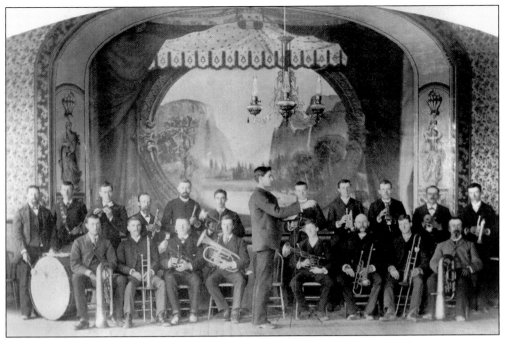

A local band plays in Weyl's Hall *c.* 1900. Large crowds packed into the hall to listen to band performances and see townspeople dressed in costumes perform in amateur theatricals. The hall was located on the second floor of Henry Weyl's building (now the Sonoma Hotel) on Spain Street. Built in 1879–1880, the lower floor held various businesses.

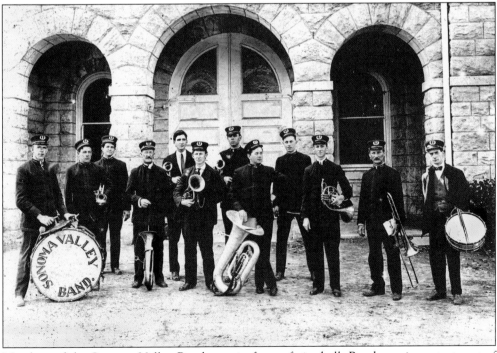

Members of the Sonoma Valley Band pose in front of city hall. Bands, an important part of Sonoma's history as early as 1868, led parades and performed concerts.

Reputedly born in 1788, Vicente Carillo poses for his 107th birthday portrait. Vicente once managed Nicolas Carriger's ranch while he was away in the gold fields. Carriger, in his 1886 will, granted Vicente and his family the right to remain on the ranch and to retain the privileges that, as manager, he had always enjoyed. His daughter Juana Bello, who was thought to be 100 at the time of her death in 1934, lived on the Morris ranch in Agua Caliente (now Hanna Boys Center) for over thirty years. She remembered stories of her family making adobe bricks for the mission.

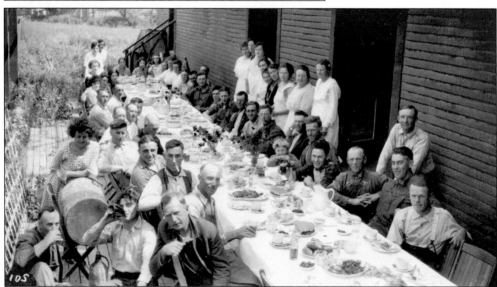

After an organized work day to improve the plaza in 1922, Native Sons and Daughters of the Golden West enjoy a banquet hosted by the Sonoma Valley Woman's Club. The Woman's Club, founded in 1901, actively worked to preserve and beautify Sonoma. They not only raised funds to help purchase and restore the Sonoma Mission property, but also built fountains and purchased benches for the plaza. They were instrumental in establishing the town's first library in 1903 in rented rooms on First Street East. Later, in 1913, the Woman's Club built a permanent library on the east side of the plaza with a $6,000 grant from the Andrew Carnegie Foundation. That building is now used by the Sonoma Valley Visitors Bureau.

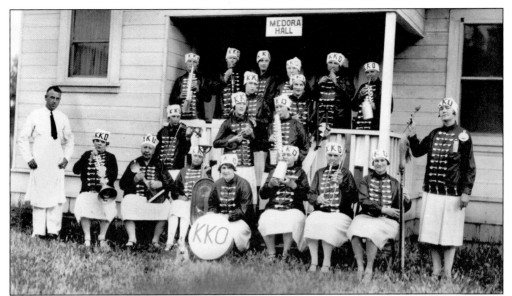

Playing old songs on kazoos and other instruments, members of the Ladies' Aid Society of the Sonoma United Methodist Church perform as the Kitchen Kabinet Orchestra. Wearing red coats decorated with spoons, they are pictured in 1930 in front of Medora Hall, the new social hall completed in 1927, for which they helped raise funds. (Courtesy Bob and Carol Kiser.)

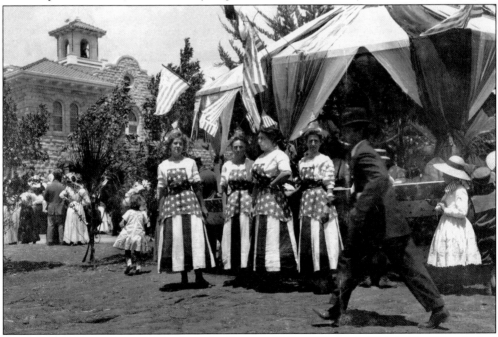

To raise money to improve the plaza, the Sonoma Valley Woman's Club held a "Carnival of Nations," from July 1 to 4, in 1910. Activities included a daily Grand Street Parade, evening concerts, and a vaudeville show. Eleven booths were built in the plaza for the event—each one representing a different region or country. The American booth, shown here, served ice cream and pie, while the plantation booth sold a complete fried chicken dinner and the gypsy booth featured a fortune teller. The event raised $1,200.

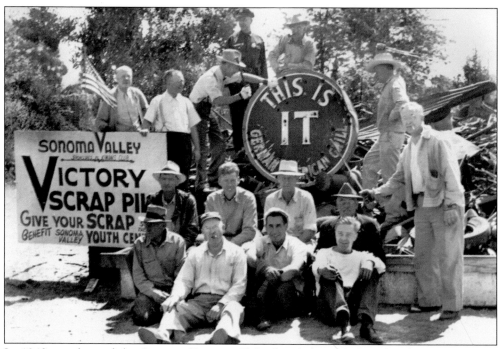

In 1943 members of the Sonoma Kiwanis Club, founded in 1925, and volunteers organize a drive to collect metal for the war effort. The money benefited the Sonoma Valley Youth Center. This event was jointly sponsored by the Sonoma Valley Chamber of Commerce and the local Sonoma Kiwanis Club. Identifiable in the photo, seated, from left to right, are (front row) Frank Canevari, Dave Kind, Herb Batto, and Dr. William J. Patterson; (second row) John Teeter, Max Johnson, Jep Valente, and unidentified. Standing, from left to right, are Ray Grinstead, W.C. Batchelder, Jack Allen, an unidentified policeman, Art Wilson, Harvey Griffin, and Dr. William Watts. (Courtesy of the Sonoma Valley Chamber of Commerce.)

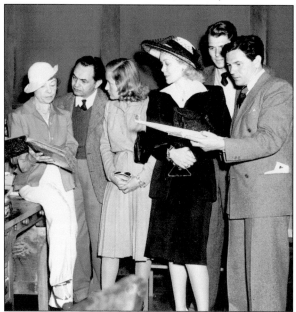

The cast of the Hollywood movie *Sea Wolf*, based on Jack London's novel, are shown here with Charmian London, Jack's widow, who is holding mementos of her late husband. Next to Mrs. London, from left to right are, Edward G. Robinson, Priscilla Lane, Jane Wyman, Ronald Reagan, and John Garfield. On March 22, 1941, the stars arrived in Sonoma and were wined and dined at a Sonoma Valley Chamber of Commerce barbecue, visited the London Ranch in Glen Ellen, and attended a premiere of the movie at the Sebastiani Theatre. (Courtesy of the Sonoma Valley Chamber of Commerce.)